IMAGES
of America

CATHOLIC
NEW YORK CITY

On the cover: Archbishop John Farley waits with a crowd at the Church of the Holy Name on 96th Street for the arrival of New York City fire commissioner Hugh Bonner's funeral procession. Bonner, who died in March 1908, was praised by Mayor George McClellan, who said, "More than any other man, Hugh Bonner was responsible for giving the New York City Fire Department its reputation as the best fire-fighting force in the world." (Library of Congress.)

IMAGES
of America

CATHOLIC
NEW YORK CITY

Richard Panchyk
Foreword by Edward Cardinal Egan

ARCADIA
PUBLISHING

Published by Arcadia Publishing
Charleston, South Carolina

Printed in the United States of America

Library of Congress Control Number: 2009922697

For all general information contact Arcadia Publishing at:
Telephone 843-853-2070
Fax 843-853-0044
E-mail sales@arcadiapublishing.com
For customer service and orders:
Toll-Free 1-888-313-2665

Visit us on the Internet at www.arcadiapublishing.com

For Erin Margaret Flynn and Lisa Kelly

CONTENTS

ACKNOWLEDGMENTS

I first want to thank all those people who have taken the time to locate and provide me with many wonderful photographs for this book, notably Erin Flynn, Ann and Michael Gardenfeld, Christine Hillman, Lisa Kelly, Jean Prommersberger, and Lori and Patrick Wallach. I also want to extend special thanks to my excellent editor Erin Vosgien, and to my family for their support. I would also like to give credit to the Library of Congress Prints and Photographs Division. Unless otherwise noted, all photographs are from the archives of the Library of Congress Prints and Photographs Division.

FOREWORD

Catholics have been an integral part of the life and fabric of New York since Colonial days. The Diocese of New York was established in 1808 and became an archdiocese in 1850. Throughout its 200 years, it has played a vital role in the growth and development of both the city and the state.

United by a common faith and anxious to become productive citizens, Catholics came to New York from a wide variety of cultures and ethnic backgrounds. In the 19th century, they were largely Irish, German, and Italian; and as the years passed, they were joined by new arrivals from other European countries and from Latin America, Asia, and Africa as well.

The history of the Catholic community in New York is particularly rich in fascinating personalities, extraordinarily active parishes, outstanding institutions of charity, and a splendid system of education. In the city of New York, the Catholic Church is growing and is more vibrant than ever before. This book provides an excellent opportunity to enjoy its history and traditions as we marvel at the splendid way it has evolved over the past two centuries.

—Edward Cardinal Egan, Archbishop of New York (2000–2009)

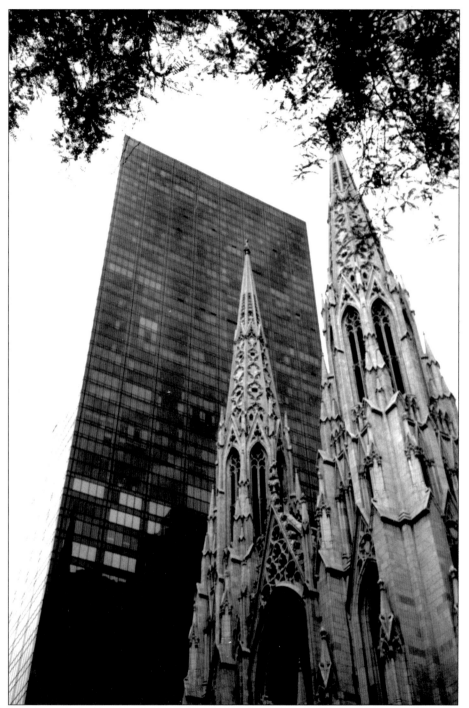

When originally built, St. Patrick's Cathedral was set against a relatively sparse background. As time passed, the neighborhood quickly filled in. Today St. Patrick's makes a pronounced appearance against the more modern buildings surrounding it. In this 1992 photograph by the author, the cathedral's spires provide a stark contrast against a steel and glass office tower. (Photograph by the author.)

INTRODUCTION

Catholic New York City has certainly come a long way on the journey to its present glory and prominence. Catholics in Colonial New York City were few and far between. From its earliest beginnings and for more than 200 years afterward, New York City was a decidedly Protestant settlement. The first wave of settlers in New Amsterdam (as it was called), arriving from the 1620s to the 1660s, were primarily Dutch Protestants. Following the British capture of the city and its name change to New York, there was a great influx of English Protestants. Roman Catholics in the Colonial city were represented by a few French, some Irish, and some Germans here and there.

By the 1780s, the Catholic population of the entire state of New York was only about 1,500. The greatest concentration of Catholics in the young nation was in Maryland, which had nearly 16,000 Catholics. It was for this reason that in 1784, Pope Pius VI named John Carroll as the bishop of Baltimore and the leader of the entire country's Catholic community. New York City's very first Catholic church, St. Peter's on Barclay Street, was finally built in 1785, more than 160 years after the settlement was begun.

It was not until 1808 that the see of New York was designated and a bishop of New York, Luke Concanen, was named. By that time there were an estimated 14,000 Catholics in the city. Unfortunately, the first bishop never made it to New York City; he was stuck in Italy under the regime of Napoleon Bonaparte and died there. As the first few decades of the 19th century progressed, the ratio of Protestant to Catholic citizens slowly began to change, but the city's growing Catholic population still did not receive the attention it deserved. By 1822, there were 20,000 Catholics in the city but only 8 priests. In fact, by 1830, there were still but four Catholic churches in the city, those of St. Peter (Barclay Street), St. Patrick (Mott Street), St. Mary (Grand Street), and St. Joseph (Sixth Avenue). By 1840, six more had been built: St. Nicholas (East 2nd Street), St. Paul (East 117th Street), St. James (James Street), Transfiguration (Mott Street), St. John the Baptist (West 30th Street), and St. John the Evangelist (East 50th Street).

As the earliest Catholic parishes in New York City were comprised predominantly of Irish, many in the German community longed to have their own identity, separate from the Irish. They desired their own church, where a focus could be placed on their language, culture, and customs. The force of their numbers helped make this a reality, and the first German church, St. Nicholas, opened in 1833 on East 2nd Street, in a heavily German neighborhood.

By 1865, there were eight German parishes in the city. These were dedicated to serving German populations and catering to the German language preferences of the communicants. In the decades that followed, several other ethnic groups also formed their own parishes as their numbers

in the city increased. In 1873, some Polish Catholics organized the St. Stanislaus B. and M. Society to collect funds to acquire a church of their own. This effort eventually led to the formation of the St. Stanislaus Parish on 7th Street. By 1914, the Italians had 35 churches, the Germans 15, the Poles 11, the Greeks 3, the Spanish 2, the Hungarians 2, and the Slovaks 2.

The Catholic population grew even more rapidly during the second half of the 19th century. The cause of this change was not due to any specific factors within New York but was primarily due to mitigating factors in Europe. Whenever conditions for the common peasant or city dweller in Europe worsened, immigration tended to increase. Poverty, hunger, civil unrest, and a growing impression that America really was the land of opportunity helped contribute to the flood of Catholic immigrants into the country. The 1848 potato famine in Ireland caused a huge influx of Irish immigrants, the great majority of them Roman Catholics. Overall annual immigration to the United States quadrupled between 1844 and 1850. Poverty and strife caused German immigration to peak between 1852 and 1854. A total of 500,000 Germans (both Catholic and Protestant) came to the United States over those three years. German immigration peaked again in 1866–1867 and between 1881 and 1885.

The surging Catholic population in New York City met with some resistance from certain elements of the population. A nationwide political party called the Know-Nothings, which was at its peak between 1851 and 1858, featured a party platform that was decidedly anti-Catholic. In 1855, the party received 146,000 votes in New York State. In New York City, however, the anti-Catholic contingent was defeated by sheer force of numbers, and the Catholic population soon grew so large that any prejudice was by far the minority.

As for Italians, their immigration numbers had remained under 5,000 before 1873 and under 10,000 until 1880. In 1900, there were 100,000 Italian immigrants arriving, and in the peak year of Italian immigration, 1907, 285,000 immigrants arrived in the country (the same year that overall immigration to the United States peaked, at over 1.2 million people).

From 1890 to 1906, the population of the United States went from 30.3 percent Catholic to 36.7 percent Catholic. In 1900, there were an estimated one million Catholics in the New York Diocese, and in 1910, there were 1.2 million Catholics in the diocese. The Diocese of Brooklyn, formed in 1853 and consisting of Brooklyn, Queens, Nassau, and Suffolk Counties, included 1.2 million Catholics.

The increasing power of the Catholic Church in New York was not simply represented in increasing numbers of churches. The Roman Catholic presence in New York has meant the establishment of a range of educational and charitable institutions. By 1900, there were 121 parish schools, 61 for boys, with 18,953 pupils; 61 for girls, with 21,199 pupils; nearly 5,000 students in colleges and academies; 2 schools for deaf mutes; 3 homes for aged; 15 hospitals; 26 industrial and reform schools; 6 orphanages; and 5 emigrant homes. By 1910, there were 180 parish schools with nearly 59,000 pupils.

With Catholics in control of Tammany Hall and on several occasions of the mayor, by the early 20th century, New York had very much become a Catholic city. As the 20th century progressed, the ethnic dynamic of the Catholic Church in New York City continued to change. Besides a continuing stream of Catholic arrivals from Europe, the city embraced a growing number of immigrants from the Caribbean, Latin America, Asia, and Africa.

Today's Catholic New York City contains a rich tapestry of ethnic groups, held together by common spiritual beliefs and all sharing a long and storied history.

One

BEGINNINGS

The foundations of Catholic New York City were laid very early in the area's history with the arrival of the Italian explorer Giovanni da Verrazano in 1524, but these foundations were not built upon until hundreds of years later with the construction of the first church in 1785. The first bishop appointed to the see of New York, Luke Concanen, never even made it out of Europe to run his diocese; from 1808 to 1815, the see was administered by Anthony Kohlmann, pastor of St. Peter's. One of his major accomplishments was the purchase of the land upon which would ultimately be built St. Patrick's Cathedral. This chapter traces the history of some of the earliest people and places of Catholic New York City, from the first Catholic priest to visit the city to the earliest Catholic inhabitants and the city's first Catholic churches. From its humble foundations, a strong and vibrant Catholic New York City would arise.

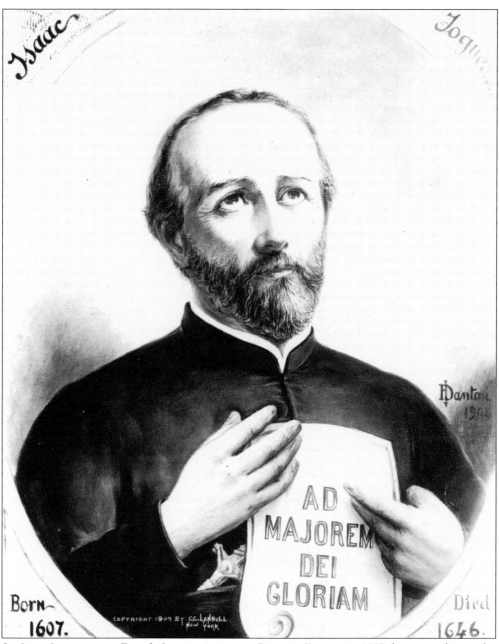

Isaac Jogues

Born Died
1607. COPYRIGHT 1909 BY CC.LANGILL 1646.
 NEW YORK

St. Isaac Jogues was a French Jesuit missionary. Born in France in 1607, he entered into the Society of Jesus in 1624. He served as a professor of literature in Rouen and then was sent to North America as a missionary in 1636. He tried to convert the Native Americans in what is now Canada and northern New York State to Catholicism but found himself in constant danger. Jogues was captured in 1642, then escaped on a ship bound for New Amsterdam just before being burned to death, thus becoming the first Catholic priest to ever visit Manhattan. He went back to Europe in 1643 but returned to the New World in 1644. He was killed by the Iroquois in 1646. Jogues was canonized by Pope Pius XI on June 29, 1930. His feast day is October 19.

A SHORT ACCOUNT

OF THE

ESTABLISHMENT

OF THE

New See of Baltimore in Maryland,

AND OF CONSECRATING THE

Right Rev. Dr. JOHN CARROLL firſt BISHOP thereof

On the Feaſt of the Aſſumption, 1790.

WITH A

DISCOURSE

DELIVERED ON THAT OCCASION,

AND THE AUTHORITY FOR CONSECRATING THE BISHOP, AND ERECTING AND ADMINISTERING THE SAID SEE,

TO WHICH ARE ADDED

EXTRACTS from the different BILLS of RIGHT and CONSTITUTION of the UNITED STATES,—That Liberty of Conſcience is the Birth-right of every Man, and an Excluſion of any religious Teſt for ever.

LONDON:

Printed by J. P. COGHLAN, No. 37, Duke-Street, Groſvenor-Square. 1790.

This book, published in London in 1790, gives a detailed account of the founding of the see of Baltimore during the 1780s. Maryland was the birthplace of the Catholic Church in America because that was where the greatest concentration of Catholics were; in 1669, there were already 2,000 Catholics in Maryland, and by 1775, there were 10,000 Catholics. The first bishop, Dr. John Carroll, reigned not only over Maryland but over the entire United States. Carroll (1735–1815), the son of Irish immigrants, was appointed by Pope Pius VI in 1784 as the prefect apostolate over the 13 states. Carroll served as the bishop of Baltimore from 1784 until 1808, and then as archbishop until his death in 1815. There were only 25 Catholic priests and 25,000 Catholics in the entire country when Carroll reigned.

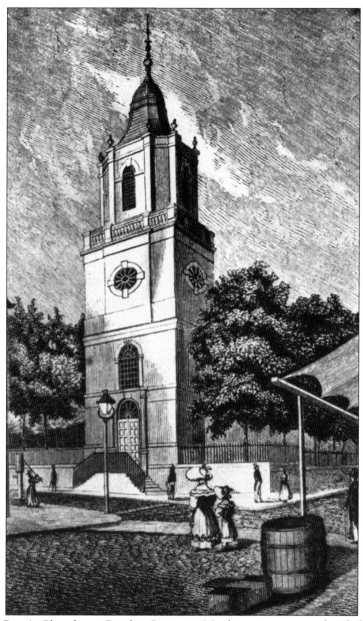

The old St. Peter's Church on Barclay Street in Manhattan was considered the "cradle of Catholicism" in New York; it was the first Catholic church built in the entire state. One impetus for the growth of the Catholic Church in New York was the evacuation of the anti-Catholic British following the Revolution. The first priest who said regular mass in New York City was Fr. Ferdinand Steinmeyer, during 1781–1782. The St. Peter's congregation was organized on June 10, 1785, and the cornerstone for the church was laid on October 5, 1785, by Don Diego de Gardoqui, the Spanish ambassador. When the first mass was said in the new church on November 4, 1786, there were only 400 Catholics in the entire city. The most prominent Catholics in the city at the time were foreigners, including Hector St. John de Crevecoeur, French consul-general; Thomas Stoughton, Spanish consul-general; and Jose Roiz Silva, the Portuguese representative. (Author's collection.)

Fifty years after the first church was constructed, St. Peter's Church was rebuilt on an enlarged plan. Bishop John DuBois laid the cornerstone in October 1836, and the work was completed in 1837 at a cost of $110,000. The church was consecrated in 1885 by Archbishop Michael Corrigan. At one point in the 1860s there were 20,000 Catholics within parish limits. This image of the church (Barclay and Church Streets) dates from 1934.

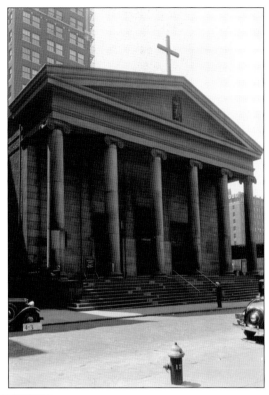

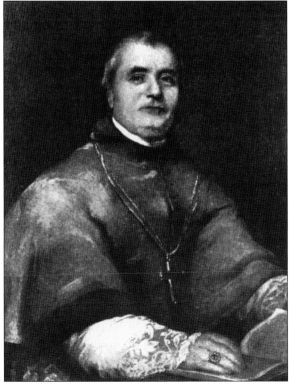

In April 1808, Pope Pius VII named a Dominican monk named Richard Luke Concanen as the first bishop of the newly created Episcopal see of New York. Concanen had been prior of San Clemente, Rome, and librarian of Santa Maria Sopra Minerva. Concanen died in 1810, before he was able to actually set foot in the United States, and so had little effect on the newly created see. (Author's collection.)

John Connolly, the second bishop of New York, was born in County Meath, Ireland. Also a Dominican, he was a professor and was only consecrated in 1814. Although appointed in 1814, he only arrived in New York in November 1815. There were only four priests in his vast diocese when he arrived. His tenure saw the construction of the Erie Canal, which helped populate Upstate New York. He oversaw the construction of several churches during his time as bishop. (Author's collection.)

John DuBois was the third bishop of New York, serving from 1826 to 1842. DuBois was a Frenchman who left during the turmoil of 1793 and went to Baltimore. He traveled extensively to Europe to get the support of his friends and contacts for the burgeoning Catholic community in the United States. During his 16 years, the Catholic population in New York went from 60,000 to 200,000, the number of churches from 6 to 30, and the number of clergy from 12 to 50. (Author's collection.)

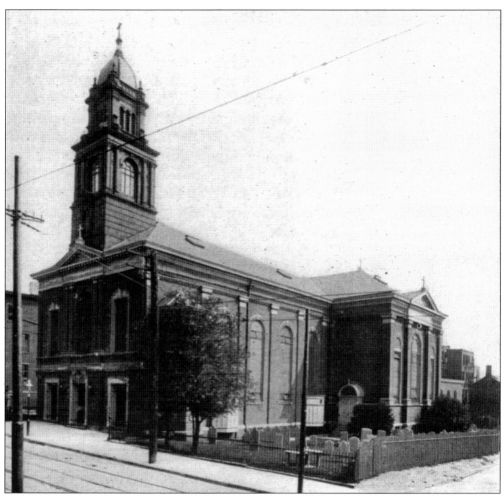

Early Brooklyn Catholics had to go to Manhattan for mass until Fr. Philip Larisey traveled to the house of William Purcell in Brooklyn to say mass during the early 19th century. Brooklyn Catholics petitioned for their own church, and a plot of land was finally purchased at Jay and Chapel Streets and blessed in 1822. The new church was dedicated by Bishop Connolly on August 28, 1823. The first resident pastor began in April 1824 at a salary of $600 per year. The St. James Pro-Cathedral (shown here) was the first Catholic church on Long Island. As of 1913, the Brooklyn diocese had 496 priests, 206 churches, 80 parochial schools with 57,000 pupils, 8 hospitals, and a total Catholic population of 700,000. (Author's collection.)

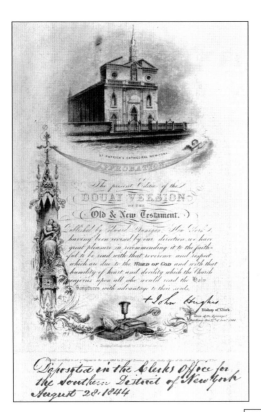

The title page of the Douay edition of the Old and New Testaments shows the old St. Patrick's Cathedral on Mott Street. The page features the signature of Bishop John Hughes and is dated June 27, 1844. The text from the bishop regarding the Douay Bible reads in part, "We have great pleasure in recommending it to the faithful to be read with that reverence and respect which are due to the Word of God."

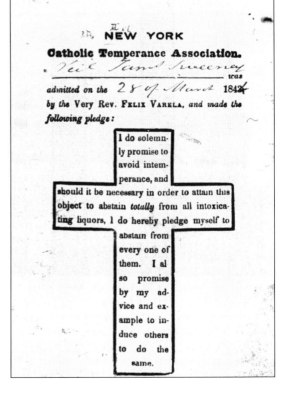

During the 19th century, temperance societies were numerous. This image shows a pledge made by Neil James Sweeney in 1844 to Fr. Felix Varela, who had been born in Cuba in 1788. Father Varela arrived in New York in 1823 and became a priest in the Irish section of the city and was involved in the Catholic Temperance Association. Father Varela was celebrated on a United States postage stamp in 1988.

The Greek Revival–style St. James Church on St. James Place in Manhattan was only the city's seventh Catholic church. Built in 1835–1836, the church was one of 10 Catholic churches built in New York between 1835 and 1845, at a time when the Catholic population was starting to grow rapidly. It is seen here in a photograph taken during the 1930s.

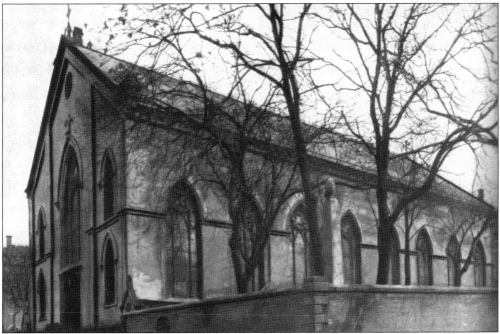

The old St. Patrick's Cathedral on Mott Street was dedicated in 1815. Mayor John Ferguson and former mayor Dewitt Clinton were present, along with a crowd of 3,000 people in the church. As the city's most prominent early Catholic church, the cathedral was the focal point of anti-Catholic sentiments. The roof was set on fire in 1835, and a mob stoned its windows in 1842. A crowd of 1,000 men threatened to burn down the cathedral in 1844, but Bishop John Hughes had 3,000 men at the ready to scare the rioters away. The church burned to the ground in October 1866, and a new one was built and dedicated in 1868. (Author's collection.)

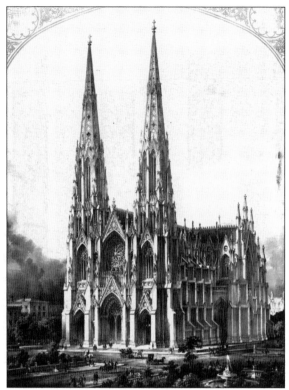

This lithograph by A. Weingartner of Fulton Street shows a rendering of the new St. Patrick's Cathedral located at Fifth Avenue between 50th and 51st Streets. Begun on August 15, 1858, the church was nowhere near complete when the somewhat fanciful lithograph was published in 1859. In fact, construction was stopped for several years due to a lack of funding and the Civil War; the doors of the new church would not actually open until 1879. Designed by James Renwick Jr. and William Rodrigue, the massive gothic cathedral instantly became a symbol of New York's Catholic life, renowned throughout the country and the world.

Following its opening in 1892, Ellis Island served as the gateway to the United States for millions of immigrants. Located in New York Harbor, Ellis Island was a welcome sight for immigrants who had just spent more than a week on a crowded ship. Unfortunately, thousands of immigrants were turned away due to health problems or lack of financial support. The first immigrant to pass through Ellis Island was a 15-year-old Irish girl from County Cork named Annie Moore. This image dates from about 1900 and shows immigrants on Ellis Island.

Countless thousands of Irish immigrants who came to New York City left small towns or villages similar to the one shown in the stereoscopic image shown at right. These Irish Catholics were used to the small churches of their communities and must have been in awe when they arrived in New York City and found Catholic churches to be large and so many in number. In the second stereoscopic image (titled "Goodbye to Old Ireland"), dating from 1903, passengers are shown on a tender at Queenstown, heading toward an ocean liner that would take them to New York.

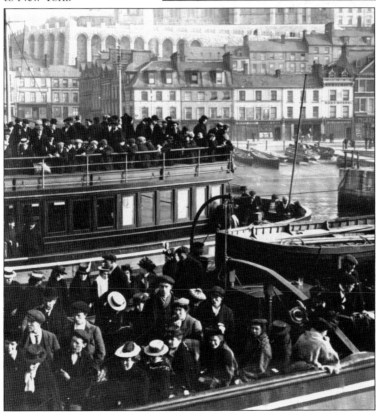

The Five Points was a notorious slum at what was then Cross, Anthony, Orange, Little Water, and Mulberry Streets. This well-known Irish Catholic tenement neighborhood also had German inhabitants. It was known for crime, violence, gangs, poverty, and disease. The slum was mostly demolished by the 1890s. An 1854 book cited "miserable-looking buildings, liquor stores innumerable, neglected children by scores, playing in rags and dirt, squalid-looking women, brutal men with black eyes and disfigured faces, proclaiming drunken brawls and fearful violence."

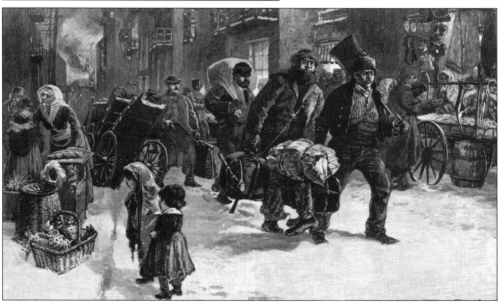

This image shows a scene on Mulberry Street on a winter evening in 1890. Mulberry Street was the center of tenement life for many Catholic immigrants. Jacob Riis wrote a book called *Out of Mulberry Street: Stories of Tenement Life in New York City* (1890). He described one apartment: "There are only three chairs, a box, and a bedstead in the room, but they take a deal of careful arranging. The bed hides the broken plaster in the wall through which the wind came in; each chair-leg stands over a rat-hole, at once to hide it and keep the rats out."

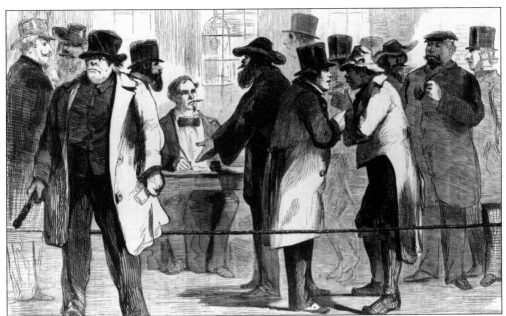

This image shows the naturalization of foreigners at Tammany Hall in 1856. To add to its roll of loyal voters, the Tammany organization opened a special bureau that paid agents to find immigrants and give them the means to obtain naturalization papers. During the first three months of 1840, 895 immigrants were naturalized at Tammany Hall, and the numbers only increased as immigration increased exponentially. A critical book published in 1856 said, "The process of naturalization (!) over, the ignorant victims are led directly to the ballot-box, the 'right ticket' is placed in their hands . . . they are pushed forward like automatons, and made To Vote!"

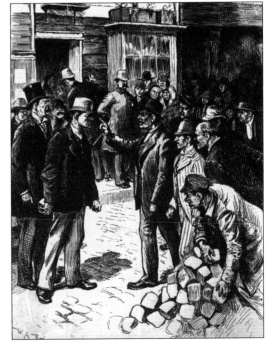

This print shows Tammany workers at the polls in Pell Street, Manhattan, in 1889. Tammany Hall had an extensive "get out the vote" organization to ensure its candidate won the election. This effort was especially focused on the many thousands of immigrants who lived on the Lower East Side.

COL. FREMONT
NOT A ROMAN CATHOLIC.

IS COL. FREMONT A ROMAN CATHOLIC.

It is not intended, by the publication of this pamphlet, to admit or concede the propriety of introducing sectarian issues into politics. Religious liberty is as important and valuable as civil liberty; and one can hardly exist without the other.

But it is now made a question of veracity between his friends and a portion of his opponents, whether Col. Fremont is or has been a Roman Catholic or not.

Let us impartially examine the evidence. It is said that Col. Fremont is a Roman Catholic—

I.—Because he was married by a Catholic Priest, and Catholic Priests never marry Protestants.

II.—Because Ex-Alderman Fulmer has stated that in March, 1852, he saw Col. Fremont joining in the religious services of a Roman Catholic Church at Washington, and that in subsequent conversation with him at dinner, at Brown's Hotel, Col. Fremont declared himself a Catholic, and a believer in the peculiar doctrines of that Church.

III.—Because in one of his exploring expeditions he made a cross upon a rock.

IV.—Because he refused to accept a Protestant hymn book when handed to him by professor Weir at West Point.

V.—Because the Rev. J. M. French has written a letter to George B. Warren, Jr., Esq., saying that he had always supposed Col. Fremont to be a Roman Catholic.

VI.—Because Mr. J. A. McMaster, editor of the *Freeman's Journal*, has written a letter saying that he can have twenty distinct affidavits of many respectable people, men and women, priests and lay, Catholic and Protestant, who will swear that for years Col. Fremont professed himself a Catholic, and denied having any other belief in any other religion.

VII.—Because of the following letter from Mr. Nathan Sargent:

WASHINGTON, Aug. 2, 1856.

A. B. Ely, Esq—Dear Sir: I have your note of the 28th of July, inquiring where Col. William Russell of Missouri resides, or may be addressed; and asking me what he has said or will say, in reference to Col. Fremont's religious opinions.

Col. Russell's residence is at Harrisonville, Cass Co., Mo., but I am informed that he is at present in Baltimore on a visit.

Col. Russell is a man who will say what he has said; and he has said to me that Col. Fremont was a Catholic when he was in California. I spent an evening with Col. R. at Brown's Hotel two or three weeks ago, and knowing that he had been much with Col. F. in California, and on very intimate terms with him, I asked him if he knew anything of Col. Fremont's religious views at that time? He replied that he did; that he was with him a great deal, and in fact might say that he had slept under the same blanket with him for eight months. I then asked him what Col. F. was? He replied, "a Catholic." I asked him if he was sure of this? "Perfectly," he said; and then added, "Col. Fremont won't deny that he was a Catholic; everybody there so understood it, and he made no secret of it."

Further conversation occurred between us on the subject, but this is the sum and substance of it. I asked him if I might refer to this conversation and use his name. He replied, "certainly; you are at liberty to do so." But he again said, "Col. Fremont won't deny that he was a Catholic."

Col. Russell, you may not be aware, was Fremont's principal witness on his trial before the Court-martial. Should Col. Fremont deny over his own signature that he was a Catholic when in California, I presume Col. Russell will then speak for himself.

Col. R. is an old, ardent, personal friend of Henry Clay, with whose family his own is connected, his daughter having married Mr. Clay's grandson. I am very truly, your obedient servant,
N. SARGENT.

Now let us investigate these several propositions, and see whether they can be maintained.

I. It is true that Col. Fremont was married by a Catholic Priest. Some opposition was made to the match by the family of Miss Benton, which rendered it necessary to have the ceremony hastily performed. It was not convenient to get a Protestant minister. The parties had resorted to the house of a friend, who procured the services of a Catholic Priest to tie the nuptial knot. No great importance, under the circumstances, was attached to the religious views of the clergyman, any way. He required no assent to them on the part of either Mr. or Mrs. Fremont.

There was at that time no well established or written rule which was closely observed, forbidding Roman Catholic Priests from performing the marriage ceremony, where both parties were Protestants. Col. Fremont's was not an isolated case of the kind, occurring in Washington, by any means.

Witness the following affidavit of a woman in that city, who states that she and her husband were both Protestants, but were married by a Catholic Priest:

District of Columbia, }
County of Washington. }

"Personally appeared before me, Benjamin K. Morsell, a Justice of the Peace, in and for the County and District aforesaid, Mrs. Marinda Leydane, widow of P. Leydane, deceased, late of the City of Washington, who being duly sworn, according to law, deponeth and says, that she was married on the 20th February, 1844, to her late husband the said P. Leydane, by the Rev. J. P. Donelan, late of St. Matthew's Roman Catholic Church of this city. Deponent avers, that she was then as also was her husband, a Protestant, and not a Roman Catholic. Deponent further avers, that she never was a Roman Catholic, and so far as she knows and believes, her husband never was one. Deponent further avers, that the said Donelan at the time she was married by him, knew her to be a Protestant, and, she believes knew her husband was not a Roman Catholic.
M. LEYDANE.

Sworn and Subscribed before me, this 2d day of Oct., 1856.
B. K. Morsell, J. P. }

District of Columbia, }
Washington County, to wit: }
I, John A. Smith, Clerk of the Circuit Court of the District of Columbia, for the County of Washington, hereby certify that Benjamin K. Morsell, Esq., before whom the above and

Shown is part of a four-page leaflet published during election season of 1856, addressing whether or not Col. John Frémont (1813–1890) was Catholic. Frémont, the newly formed Republican Party's candidate for president, was dogged by rumors. Various arguments were presented and countered in this leaflet, including Frémont's marriage by a Catholic priest. A letter from New York's Archbishop Hughes was included: "[as regards] any charges which could fix a stain on the private or personal character of Col. Frémont, the Archbishop knows nothing of his own knowledge, and therefore has not made, nor authorized anyone to make, an accusation against Mr. Frémont." Frémont lost the election to James Buchanan and died a broken man in New York City.

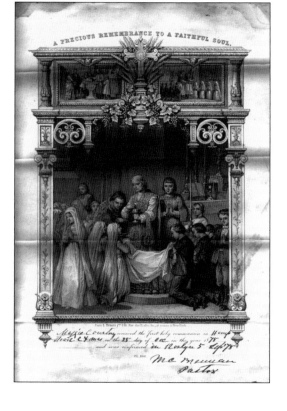

This engraved certificate was given to Maggie Courtney (born in 1865 in Queens County) in remembrance of her confirmation in September 1878 at Roslyn and her first communion on Christmas Day 1878 in Hempstead. Before the 1880s, the number of Catholic churches in Queens County was extremely limited. (Jean Prommersberger.)

Two

PROMINENT PEOPLE

New York City's history is rich with colorful Catholic personalities from all walks of life. During the late 19th and early 20th centuries, Catholics ruled the city as the population exploded due to an influx of European Catholic immigrants. During this time, several Catholic mayors were elected, and the city's powerful Democratic machine, Tammany Hall, was run by Catholics. In addition to the many cultural and political contributions of Catholic laity, New York's church leaders (as well as the Holy Father himself, the pope) have of course played a major role. The city's priests, bishops, archbishops, and cardinals have provided spiritual leadership for the city's Catholic population for more than 200 years, since the founding of the diocese in 1808. They strive to continue ensuring New York City's prominence as one of the country's largest and most influential Catholic centers.

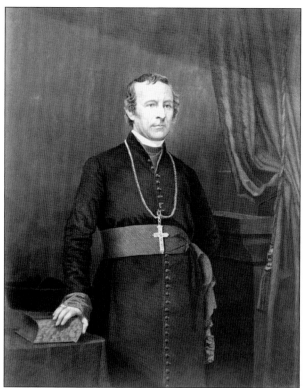

John Hughes (1797–1864) was the fourth bishop and first archbishop of New York. He was born in Ireland and came to America in 1817. Educated in Maryland, he spent time in Pennsylvania before being named by Bishop John DuBois as coadjutor of New York in 1838. In 1839, he became administrator-apostolic of New York and in 1842 was named bishop. He was elevated to archbishop of New York in 1850, during the peak of Irish immigration.

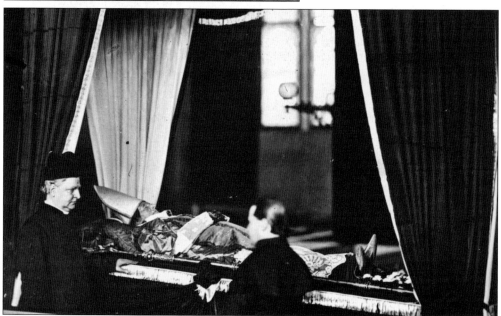

Archbishop John Hughes died at his residence on Madison Avenue in early January 1864. On January 5, he laid in state at the old St. Patrick's Cathedral on Mott Street. In the center aisle near the altar was a platform covered with a black cloth, illuminated with candles. His body lay atop that catafalque. More than 20,000 people came to pay their respects. The body again laid in state on the 6th and the funeral was at the cathedral on the 7th.

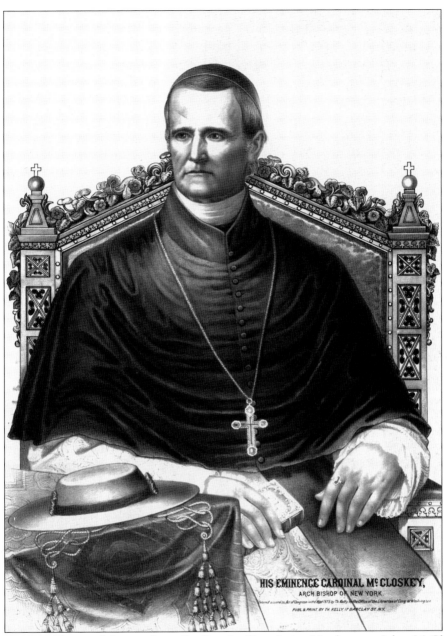

HIS EMINENCE CARDINAL McCLOSKEY,
ARCH BISHOP OF NEW YORK.

Entered according to Act of Congress in the Year 1875 by Th. Kelly in the Office of the Librarian of Cong. at Washington.

PUBL. & PRINT. BY TH. KELLY, 17 BARCLAY ST. N.Y.

Born in Brooklyn and baptized at St. Peter's Church in Manhattan, John McCloskey (1810–1885) was the son of Irish immigrants from County Derry. When he was born, Brooklyn did not yet have a Catholic church, and so his family rowed across the East River to attend mass in Manhattan. When he was seven, his family moved to Manhattan. He attended Thomas Brady's Latin School and was ordained a priest in 1834. He became a professor in the Nyack Seminary and then was named bishop of Albany in 1847. He was named archbishop of New York in 1864. On March 15, 1875, Pope Pius IX named him as the first cardinal of the western hemisphere. Cardinal McCloskey oversaw the completion of St. Patrick's Cathedral, which had been started under his predecessor, Cardinal Hughes. Cardinal McCloskey is buried under the high altar of St. Patrick's Cathedral.

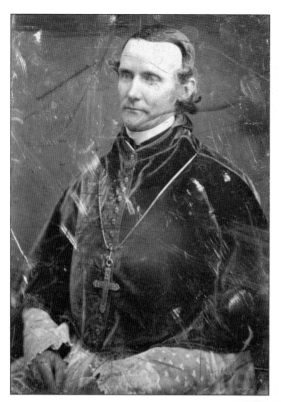

John Cardinal McCloskey is seen here in an early photograph. By the end of his tenure, there were 600,000 Catholics in the diocese, served by 285 diocesan priests and 119 regular priests. There were 176 churches, 60 chapels, and 8 orphanages. By his death in 1885, there were more than 33,000 students in the diocesan schools.

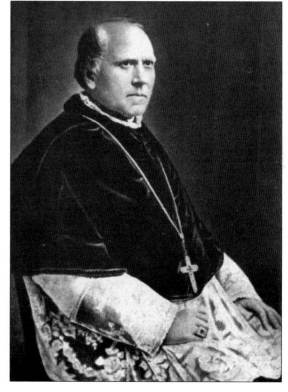

John Loughlin (1817–1891) was born in County Down, Ireland. He served as the first bishop of Brooklyn from 1853 to 1891. When his tenure began, there were only 12 Catholic churches on Long Island. While he was bishop, 125 churches and chapels were built in his see and the Catholic population of Long Island increased by 385,000 people.

Charles E. McDonnell (1854–1921) was born in New York City and ordained a priest in 1878. He later became secretary to Cardinal McCloskey. He became the second bishop of Brooklyn in 1892. His funeral was attended by 2 archbishops and 23 bishops. He is buried in the crypt of the St. James Cathedral at Jay Street in Brooklyn.

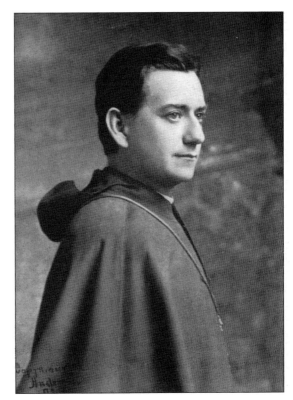

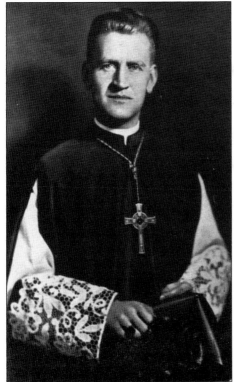

Raymond A. Kearney (1902–1956) was appointed as the auxiliary bishop of Brooklyn in 1934. He was the youngest bishop in the United States at the time and was the first bishop in the world to have been born in the 20th century. At the time of his appointment, his diocese had the third-largest population of any diocese in the country. Kearney was also titular bishop of Lisinia (Asia Minor). (Jean Prommersberger.)

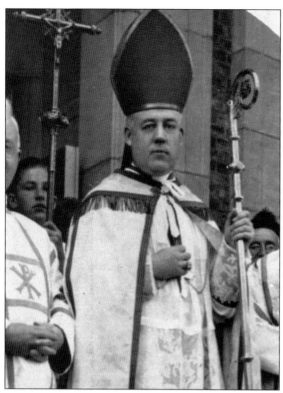

Thomas E. Molloy (1884–1956) was the third bishop of Brooklyn. He became archbishop of Brooklyn in 1951. His legacy was great. He led the establishment of 90 parishes and 100 elementary schools in Brooklyn, Queens, Nassau, and Suffolk Counties. In this image, Bishop Molloy visits the Chaminade High School in Mineola in 1946. (Jean Prommersberger.)

John M. Farley (1842–1918) was born in Ireland and came to the United States in 1864. He became archbishop of New York in 1902 and was named cardinal in 1911. It was during his tenure that the peak of immigration to the United States occurred, and the influx of Catholics into New York reached a crescendo, with large numbers of Italians arriving during the first decade of the 20th century.

30

Patrick J. Hayes (1867–1938) was born in New York City, the son of Irish immigrants. He was ordained a priest in 1892. In 1914, he was appointed auxiliary bishop of New York, and during World War I he was named bishop of the American armed forces. In 1919, he was named archbishop of New York, and in 1924, he was elevated to cardinal. His nickname was the "Cardinal of Charities" because of his extensive activity in charitable causes.

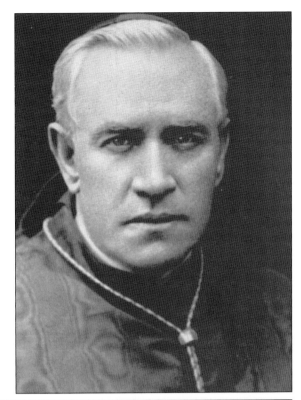

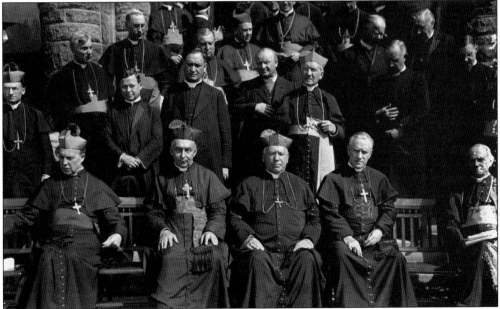

This image shows Patrick Cardinal Hayes, archbishop of New York; William Cardinal O'Connell (1859–1944) of Boston; and George Cardinal Mundelein (1872–1939) of Chicago together on September 24, 1924. Cardinal Mundelein was born in New York City and ordained a priest in Brooklyn in 1895 before becoming archbishop of Chicago in 1915. He was elevated to cardinal in March 1924.

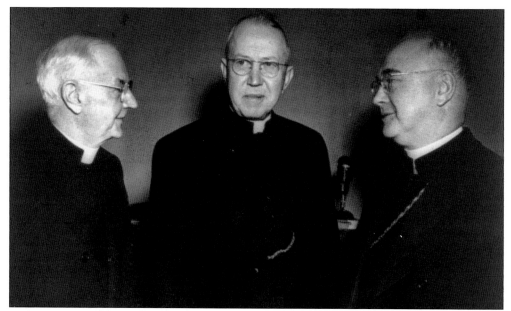

This image shows, from left to right, a meeting of Samuel Cardinal Stritch (1887–1958, archbishop of Chicago), Edward Cardinal Mooney (1882–1958, archbishop of Detroit), and Francis Cardinal Spellman (1889–1967, archbishop of New York). Spellman, the sixth archbishop of New York, was elevated to cardinal in 1946 and is buried in St. Patrick's Cathedral.

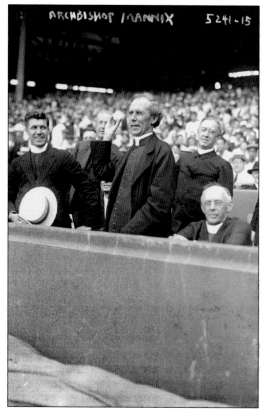

Daniel Mannix (1864–1963) was born in Ireland and ordained as a priest there in 1890. He moved to Australia in 1913 and was named archbishop in 1917. A supporter of Irish independence, he visited New York City in 1920. A crowd of 15,000 people (the majority probably Irish) squeezed into Madison Square Garden to see the archbishop. Two hundred and thirty policemen were needed to maintain order. While in the city, Archbishop Mannix also said mass at St. Patrick's Cathedral and threw out a ball at the Polo Grounds baseball field.

Pope Pius IX, Giovanni Maria Mastai-Ferretti (1792–1878), was beatified in 2000. He reigned from 1846 to 1878, a time of great strife among Catholics in Europe, who were dealing with poverty, famine, and civil war. Accordingly, it was also a time of great growth in the Catholic population in the United States, as immigrants from Ireland and Germany began to flood into New York.

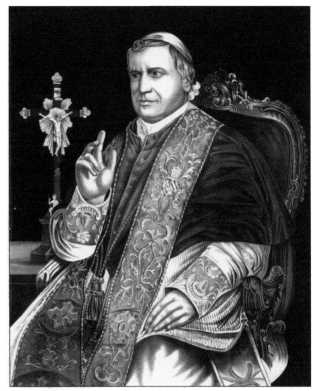

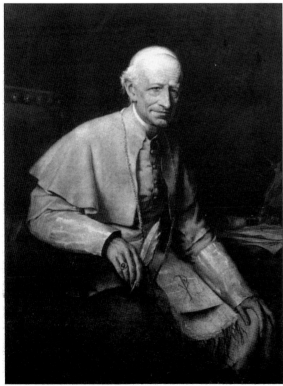

Pope Leo XIII (Count Vincenzo Gioacchino Raffaele Luigi Pecci) was born in 1810, elevated in 1878, and died in 1903. He was admired in the United States, and during his reign, more than 11 million immigrants arrived in the country, including hundreds of thousands of Catholics who remained in New York City.

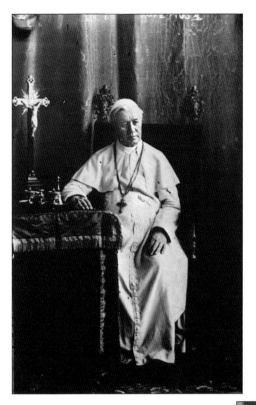

Pope St. Pius X (Giuseppe Melchiorre Sarto) was born in 1835, was named a cardinal in 1893, elevated to pope in 1903, and died in 1914. It was during his tenure that the peak year of European immigration to the United States occurred (1907).

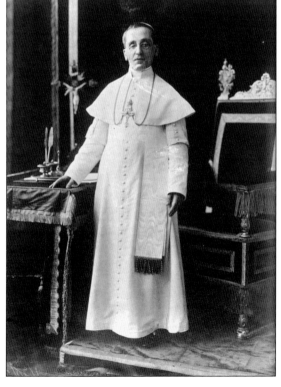

Pope Benedict XV (Giacomo della Chiesa) was born in 1854. He was elected pope in 1914, just as World War I was starting. He declared neutrality of the Vatican and tried to mediate peace, circulating peace proposals, but his efforts were not welcomed by most world leaders. Pres. Woodrow Wilson did, however, eventually embrace some of Benedict XV's principles. The pope died in 1922.

Pope Pius XI (1857–1939) was born Achille Ratti. Ordained in 1879, he became archbishop of Milan in 1921 and ascended to the papal throne in 1922. He faced difficult relationships with fascist governments of Italy and Germany. A concordat was signed with Adolf Hitler in 1933, but he issued an encyclical in 1937 that condemned the Nazis. Americans had mixed feelings about him.

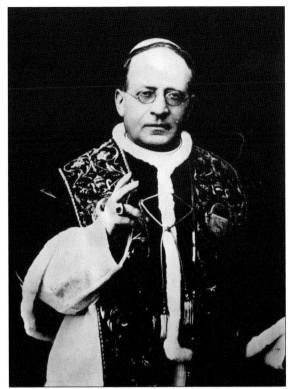

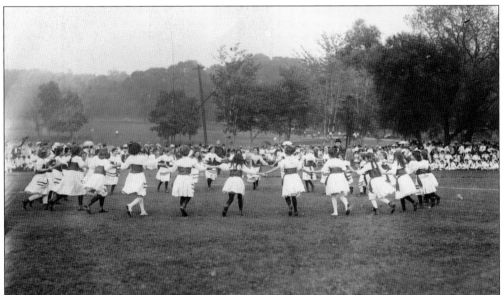

The three largest Catholic ethnic groups in New York City until the mid-20th century were the Irish, Italians, and Germans. To a lesser but still very important extent, dozens of other countries were represented in the makeup of Catholic New York City, including Hungarians. In this image, a crowd of thousands watch Hungarian-American schoolchildren perform a folk dance in Van Cortlandt Park in the Bronx during a meeting of the Playground Association in September 1908.

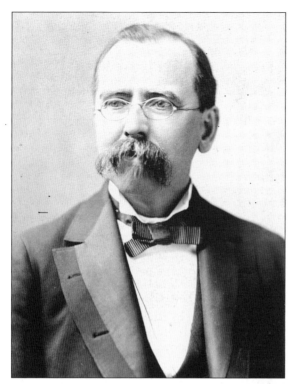

William Russell Grace, the first Catholic mayor of New York City, was born in 1832 in County Cork, Ireland. He left in 1846 for the United States, then lived in Peru for several years, engaging in the shipping business. He moved to New York in 1866 and founded W. R Grace and Company in 1868. He ran for mayor in 1880 and 1884. He died in New York City in 1904. During his term in office, the Statue of Liberty was received from France.

This cartoon shows Mayor William Strong (1827–1900) dressed as "New York's St. Patrick," driving away the Tammany heelers, Tammany-ites, and Tammany office holders (depicted as snakes and frogs) from city hall with a pointed staff. The cartoon, drawn by Frederick Burr Opfer, was published on March 20, 1895, in *Puck* magazine.

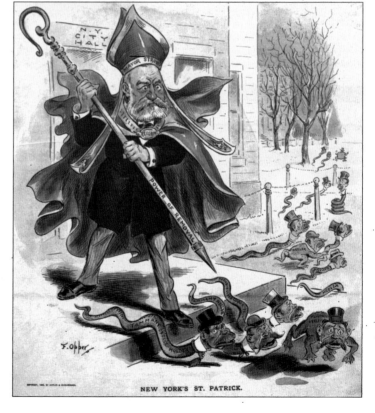

NEW YORK'S ST. PATRICK.

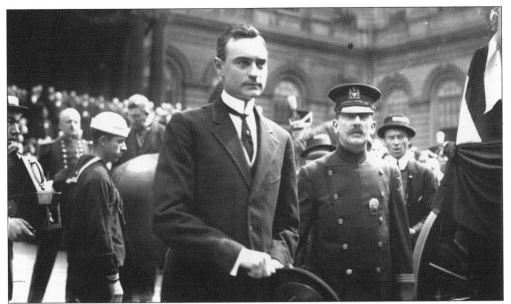

The politician John Purroy Mitchel (1879–1918) was raised by Irish Catholic parents in the Fordham section of the Bronx. He was elected president of the Board of New York City Aldermen in 1909. He soon became the youngest mayor in the city's history, at the age of 34. He served in that capacity from 1914 to 1917.

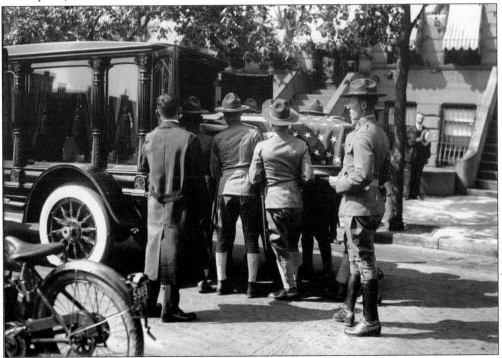

Former mayor John Purroy Mitchel enlisted in the army aviation corps soon after not winning reelection. He was killed while in training on July 6, 1918, not yet having reached the age of 40. Funeral services were held on July 11 in St. Patrick's Cathedral, which was filled to capacity. Mitchel Field on Long Island was named after the late mayor and war hero.

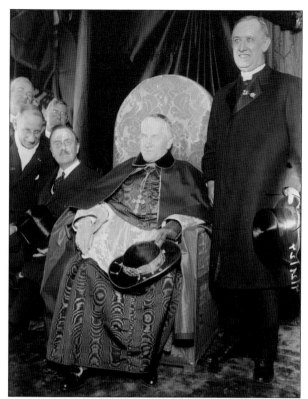

Mayor John Hylan (left) is seen here with the archbishop of New York, Patrick Cardinal Hayes (center), and Bishop John Dunn. Dunn was elevated to bishop in 1921. He served for 17 years as the director of the New York branch of the Society for the Propagation of the Faith and continued to serve as the chairman after becoming bishop. He pontificated at vespers for the society in St. Patrick's Cathedral on December 4, 1921.

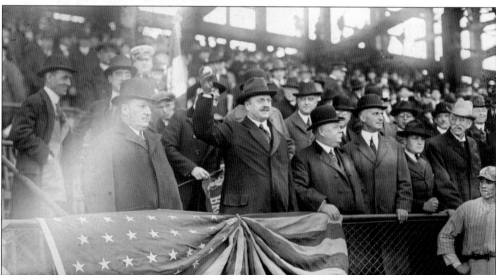

Catholic mayor John Francis Hylan throws out the first ceremonial pitch of the 1920 World Series at the Polo Grounds. The Cleveland Indians beat the Brooklyn Dodgers 5-2 in that series. During his tenure as mayor, Yankee Stadium was built. John F. Hylan (1868–1936) was the 96th mayor of New York City, from 1918 to 1925. First serving as a judge in Brooklyn, he was a successful Tammany Hall candidate. After a second term in office, however, he was defeated for renomination by the next mayor (also Catholic) James Walker. He died at his home in Forest Hills, Queens.

Mayor James (Jimmy) Walker (1881–1946) was actually a songwriter before becoming a politician. One of his well-known songs was called "Will You Love Me in December as You Do in May." He served in the state assembly from 1910 to 1914, and then in the state senate from 1923 to 1925. He became mayor in 1926. Nicknamed "Night Mayor" and "Beau James," his colorful and larger-than-life personality was well known throughout the city. Among his vices during his time as mayor were extensive vacations overseas. He won reelection over opponent Fiorello Henry LaGuardia but resigned in September 1932 under a state legislature investigation of alleged corruption. His image was somewhat restored in 1940, when Mayor LaGuardia appointed him as municipal arbiter to the garment industry. He was portrayed by Bob Hope in a biographical movie released in 1957.

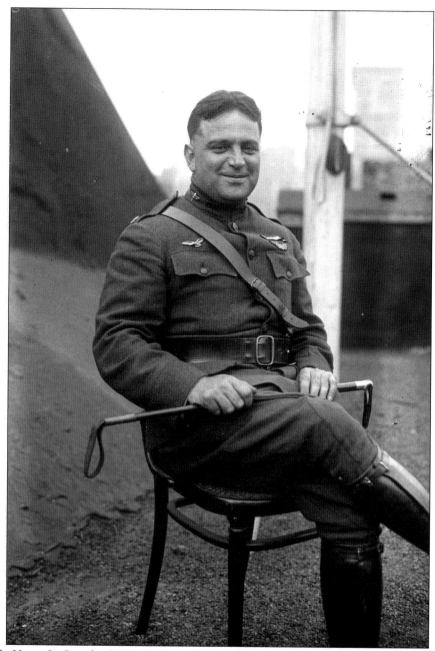

Fiorello Henry LaGuardia (1882–1947) was born in New York City of an Italian Catholic father and a Hungarian Jewish mother. He led a long life of public service, beginning with a stint in the American Consular Service in Budapest, Hungary, and in Trieste, Austria, 1901–1904. He was also an interpreter in the Immigration Service at Ellis Island from 1907 to 1910; deputy attorney general of the State of New York from 1915 to 1917; and a congressman from 1917 until 1919. While in Congress, he was commissioned as first lieutenant in the U.S. Army Air Service and promoted to the rank of major. He was president of the board of aldermen of New York City in 1920 and 1921 and was again in Congress from 1923 to 1933. He was mayor of New York City from 1934 to 1945. He is shown here in uniform during World War I.

The Wagners were a famous German father-and-son political force in New York City. Robert Ferdinand Wagner (1877–1953) was born in Hesse-Nassau and arrived in New York in 1885, attending New York City public schools. He attended City College, graduated in 1898, and went on to a career in public service. He was elected United States senator in 1926 and served four terms (1927–1945). He played a major role in implementing the Social Security Act and the Wagner Labor Act in 1935. His son Robert F. Wagner Jr. (1910–1991) served three terms as mayor of New York City (1954–1965) and helped oversee the city's hosting of the world's fair in 1964–1965. This photograph shows Robert Ferdinand Wagner Sr.

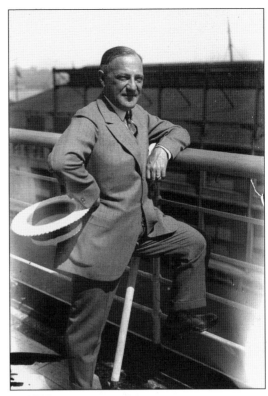

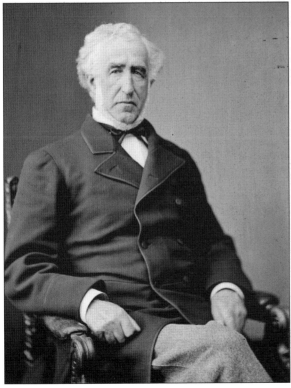

Francis Kernan (1816–1892) was born in Steuben County, the son of Gen. William Kernan, an Irish immigrant. He served as congressman from 1863 to 1865, ran for governor in 1872, and was a United States senator from 1875 to 1881. A devout Catholic, he was a Democratic Party leader; although associated with Upstate New York, he was well known in New York City.

41

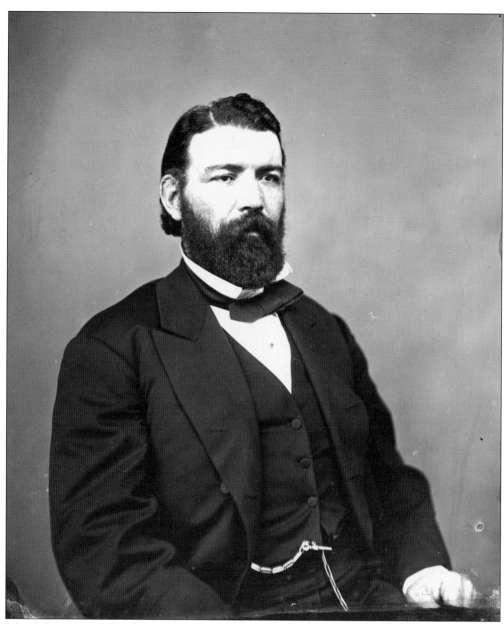

John Morrissey (1831–1878) was born in County Tipperary, Ireland. He came to the United States at the age of two and had a wide range of adventures before moving to New York City in adulthood. His diverse resume included serving as a factory worker, an entrepreneur, and being a gang member, among other things. He made a fortune owning and operating gambling houses and also being a famous boxer. Morrissey was champion heavyweight boxer of the world after winning a fight against John C. Heenan (and a prize of $2,500) in October 1858. He then began a career in politics, getting elected to Congress as a Democrat and serving from 1867 to 1871. He was elected to the New York State Senate in 1875. He was reelected in 1877 but fell sick and died in Saratoga Springs shortly afterward.

"Honest John" Kelly (1822–1886) was a New York congressman from 1859 to 1862 and again from 1865 to 1867. He became a widower and then married the niece of Cardinal John McCloskey. Kelly also ran Tammany Hall from 1874 to 1886, succeeding the corrupt William "Boss" Tweed, and was a very powerful and prominent figure in local politics. Following his death, numerous speakers paid tribute to him at a meeting at Tammany Hall. The publisher Charles Dana said, "He was a Democrat not only in his thoughts, but in blood and bones. He was a Democrat morning, noon, and night, and all the time. He believed in the rule of the people, for the people, and by the people." He is buried at the old St. Patrick's Cathedral on Mott Street in Manhattan; more than 7,000 people attended the funeral.

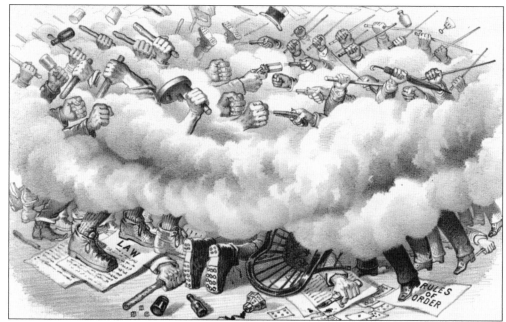

This Currier and Ives print from 1876 is titled "Democratic Reformers in Search of a Head" and pokes fun at the infighting among New York Democrats preceding the 1876 presidential election. Tammany leader "Honest John" Kelly exerted influence in opposition of New York governor Samuel Tilden's bid for the Democratic presidential nomination. The Kelly followers are parodied on the left side of the print with work shoes and clubs and bottles as weapons, while the Tildenites are shown with dress shoes, wielding canes, guns, and umbrellas as weapons.

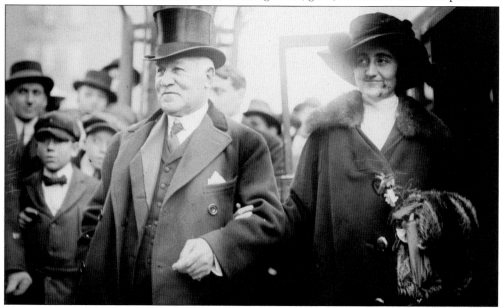

Richard Croker (1843–1922) came to the United States at the age of two. He became a city alderman and served from 1868 to 1870. He was then coroner from 1873 to 1876 and next fire commissioner from 1883 to 1887. He was leader of Tammany Hall after the fall of "Honest John" Kelly in 1886 and served in that capacity for more than 10 years.

This image from the cover of *Puck* magazine in 1903 shows Tammany leader Richard Croker nailing a George McClellan figurehead to the Tammany ship, with a caption reading, "Merely another figurehead." This cartoon implied that Mayor McClellan was in the pocket of Croker. Croker eventually retired from New York City politics and returned to Ireland, where he died in 1922.

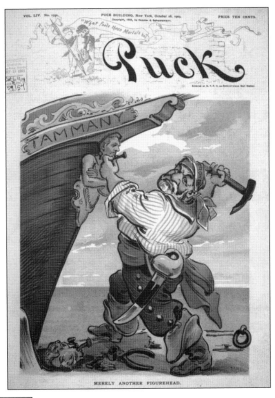

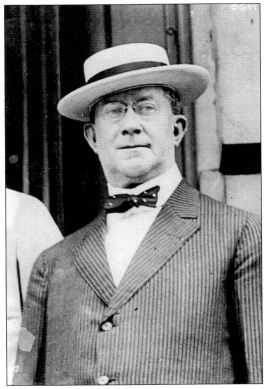

Charles F. Murphy (1858–1924) followed Richard Croker as head of Tammany Hall in 1902. Very powerful, he first headed the "Gas House District" of the city. A prominent local figure in Democratic politics, he helped bring about the election of several prominent New York politicians, including several mayors and Gov. Al Smith.

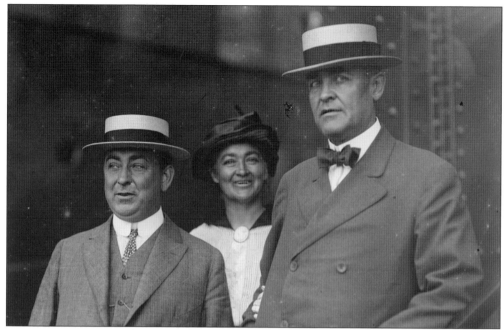

Timothy Daniel Sullivan, also known as "Big Tim" Sullivan, was a larger-than-life figure in Irish American Tammany Hall politics. A businessman who was also involved in real estate, Sullivan was a member of the New York State Assembly from 1886 to 1894; a member of the New York state senate from 1894 to 1903 and 1909 to 1912; and was a congressman from 1903 to 1906. He is seen here in an undated photograph with his brother-in-law Larry Mulligan.

John D. Crimmins (1844–1917) was a New York City contractor whose company had built the city's elevated train system. He was president of the Society of the Friendly Sons of St. Patrick. When he died, he left a $5 million fortune, including a bequest of $25,000 to St. Patrick's Cathedral.

Christopher D. Sullivan (1870–1942) was one of the last bosses of Tammany Hall. Sullivan attended St. Mary's Academy and was elected to the New York State Senate in 1906, serving until 1916. He was then elected to Congress and served from 1917 to 1941. He is buried in Calvary Cemetery in Woodside, Queens.

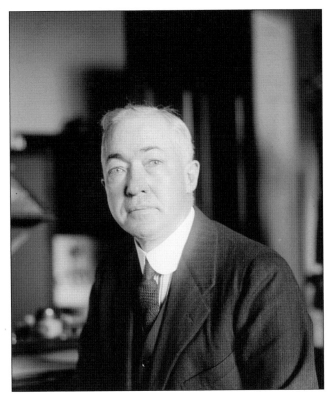

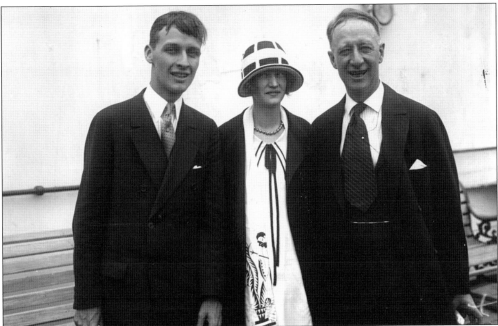

Alfred E. (Al) Smith (1873–1944) was one of the most well known and powerful Catholic figures in New York political history. He was governor of New York from 1922 to 1928 and was a mentor to Franklin D. Roosevelt. He was the Democratic nominee for president in 1928 but lost the general election to the Republican Herbert Hoover. He is seen here (at right) during the 1920s.

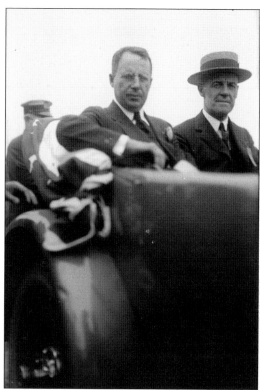

James Cox (left), the 1920 Democratic nominee for president, rides in a car with New York Catholic politician Al Smith in this undated photograph. Smith and Cox were the two biggest stars of the Democratic Party during the 1920s.

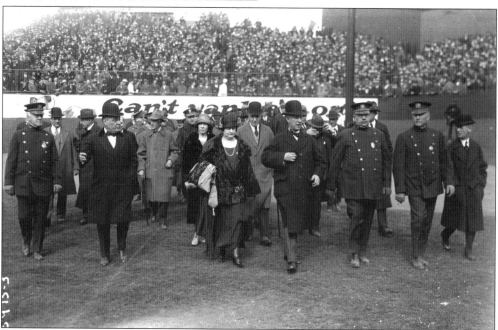

Jacob Ruppert, the German Catholic owner of the New York Yankees, and Catholic New York State governor Al Smith and his wife attend the opening game at the brand-new Yankee Stadium on April 18, 1923. The Yankees beat the Red Sox 4-1. The final game at the original Yankee Stadium took place on September 21, 2008.

After his death in 1944, Al Smith was celebrated in a United States postage stamp release. The 3¢ stamp was released on November 26, 1945, in honor of the former governor's long service to New York and national politics. (Author's collection.)

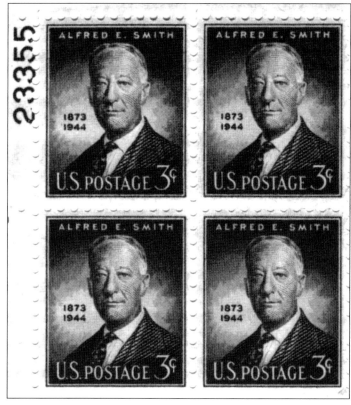

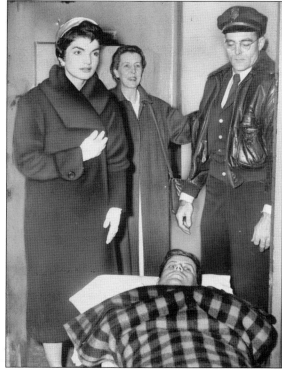

Sen. John F. Kennedy leaves a New York City hospital on a gurney following spinal surgery as wife Jacqueline stands beside him. Kennedy was plagued by back problems throughout his life, following an injury sustained during World War II. He left the hospital on December 21, 1954, after an extended stay.

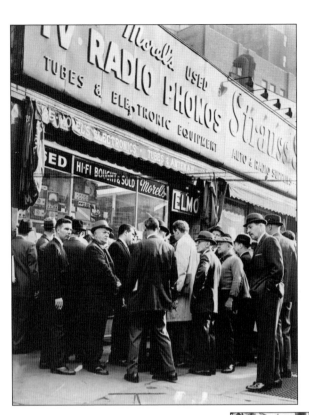

Although John F. Kennedy only defeated Richard Nixon in New York State by a margin of five percent, he won heavily in largely Catholic New York City. New Yorkers were always partial to the Massachusetts native, the country's first Catholic president. In this image, a shocked crowd on Dey Street in Manhattan listens for news on the status of Pres. John F. Kennedy in November 1963, just after the president was shot in Dallas. As fellow Catholics, many New Yorkers felt an extra special affinity for the president, and his loss was deeply felt in the city.

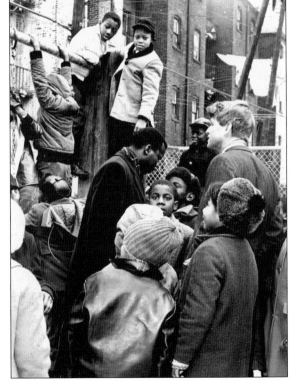

Robert F. Kennedy, originally from Massachusetts, was a United States senator representing New York State from 1965 until his death in 1968. Although born in Massachusetts, he moved to Riverdale in the Bronx in 1927, and then to Bronxville. Among other accomplishments, Kennedy helped start a redevelopment project in Bedford-Stuyvesant, Brooklyn. In this image, Kennedy stands with Donald F. Benjamin (center) of the Central Brooklyn Coordinating Council.

Msgr. Charles McCready was rector of Holy Cross Church at West 42nd Street for 35 years. He was born in County Donegal, Ireland, and arrived in the United States in 1864. He was ordained a priest in the old St. Patrick's Cathedral in 1866 by Cardinal John McCloskey. He was first assigned to the old Church of St. John the Evangelist on 50th Street. He was then assigned to St. Andrew's parish, and then in 1877 to Holy Cross Church. He died in 1915.

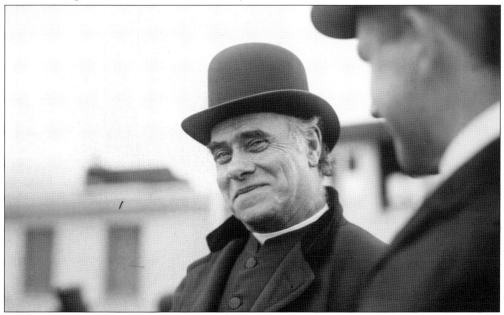

This image shows James H. McGean of St. Peter's Church on Barclay Street around 1910. McGean graduated from St. Francis Xavier's College in 1861 and was ordained at St. Patrick's Cathedral in 1864. He was assigned to the Church of the Transfiguration in 1871 and to St. Peter's in 1881. He assisted in the blessing ceremony for a new 1,500-pound bell installed in the old St. Patrick's Cathedral in 1906.

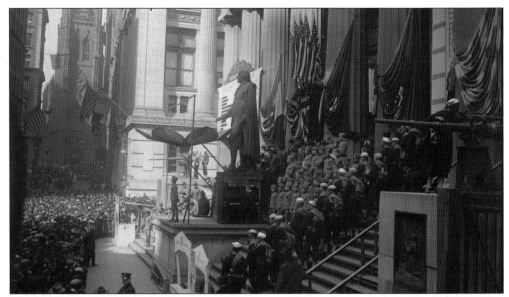

The Paulist Choir of New York was founded by Fr. William Finn, who had worked with the famous Paulist Choir of Chicago. In 1918, he brought a group of boys to New York City and started the group, which was about 70 voices strong. His assistant director was Eugene O'Malley. This photograph shows the Paulist Choir on the steps of Federal Hall, around 1920.

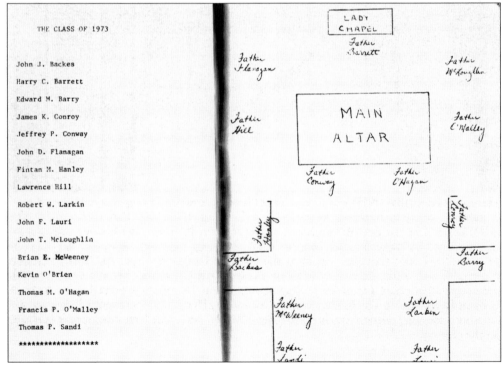

This page is from the program of the ordination ceremony held at St. Patrick's Cathedral on May 26, 1973. On that day, 16 men were ordained as priests. With the number of priests dwindling in recent years, the Roman Catholic dioceses of New York and Brooklyn are actively encouraging vocations to ensure that New York churches are adequately staffed. (Christine Hillman.)

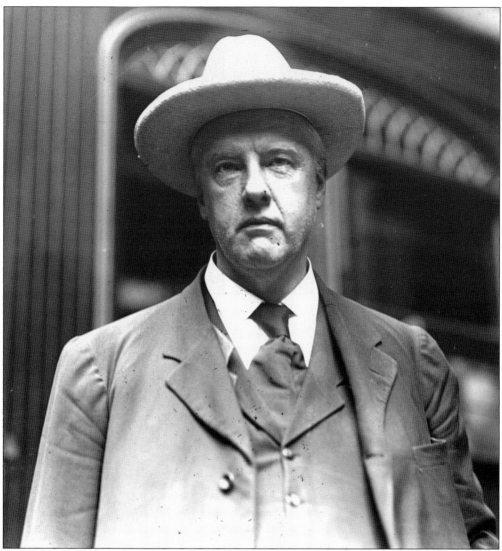

Herman Ridder (1851–1915) was a prominent German American newspaper publisher. Born in Manhattan of German parents, he established the German-language *Katholisches Volksblatt* in 1878, followed by the English-language *Catholic News* in 1888. He later became publisher and editor of the *New Yorker Staats-Zeitung*, a German-language New York newspaper. He was active in many local civic activities, including the Catholic Protectory, Legal Aid Society, German Hospital Board, and Charity Organization Society. In 1908, Ridder became treasurer of the Democratic National Committee, an important position. Intermediate School 98 in the Bronx is named after Ridder. The Ridder company founded by Herman Ridder eventually merged with another publishing operation to become Knight Ridder, one of the largest newspaper publishers in the country.

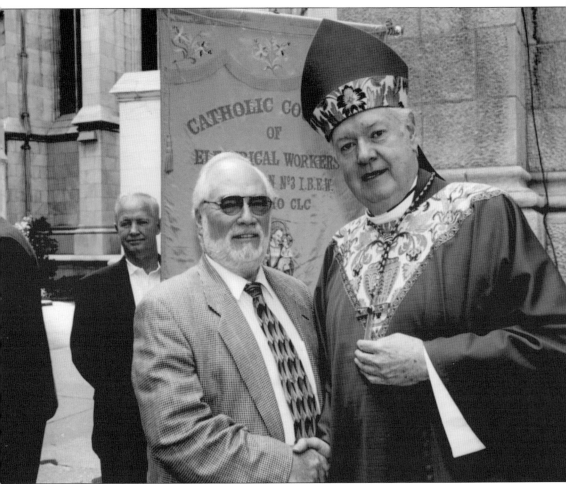

Michael Gardenfeld meets archbishop of New York Edward Cardinal Egan in front of St. Patrick's Cathedral. Gardenfeld (who grew up in Flushing, Queens), the past president of the New York City Catholic Council of Electrical Workers, joined the group for its annual communion breakfast mass at the cathedral, which was followed by a breakfast at a local hotel. For this 2006 mass, the cardinal was present and posed for photographs outside the cathedral. Edward Cardinal Egan was ordained in 1985, appointed as archbishop of New York in 2000, and elevated to cardinal in 2001. In 2002, Pope John Paul II named Cardinal Egan to the Supreme Tribunal of the Apostolic Signature. He was replaced as archbishop in April 2009 by Timothy Dolan, former archbishop of Milwaukee. (Michael Gardenfeld.)

Three

CATHOLIC LIFE

The story of New York City's Catholics is told not only through the famous and powerful Catholics of the city, it is also especially visible in the lives of the millions of everyday people, each with their own unique story of Catholic faith and heritage. New York is an amazing place because its Catholics come from all kinds of diverse ethnic and social backgrounds and live in all corners of the city, from the northernmost reaches of the Bronx, to the distant western coast of Staten Island, to the easternmost border of Queens. One thing that all New York City Catholics have in common is the religious rites that they all share. These milestones in Catholic life are celebrations for families to remember. Baptism, First Holy Communion, and confirmation are three important occasions in every Catholic child's life. Although many things have changed over the years, the importance of the sacraments has not, as will be seen in this chapter. Each Catholic's special day has a story behind it, and each story helps contribute to the colorful quilt of Catholic New York City.

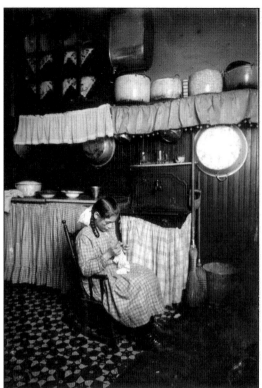

Twelve-year-old Carmela Picciano is captured in this photograph taken in January 1912. She lived at 311 East 149th Street on the third floor, in the rear apartment. Picciano is seen here making Irish lace for collars. Sometimes she worked until 9:00 p.m. to bring in extra money for her family. Picciano was photographed by Lewis Wickes Hine, prominent photographic documenter of immigrants.

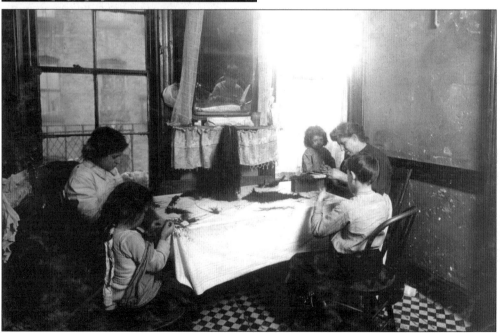

Mary Molinari and family lived at 304 East 107th Street. Mary sits with her nine-year-old daughter Annie, who worked in a shirtwaist factory; son Dominick, also nine; and younger daughter Antoinette, age six. This image was taken in January 1912 by the famous photographer Lewis Wickes Hine.

In this image by the noted photographer Lewis Wickes Hine, Frank Villanello, a young New Yorker of Italian descent, poses for the camera. Frank stands at 21 Greenwich Avenue, at his father's shoeshine stand in July 1910. Most children of Catholic immigrants to New York began working at a young age in order to help support their families.

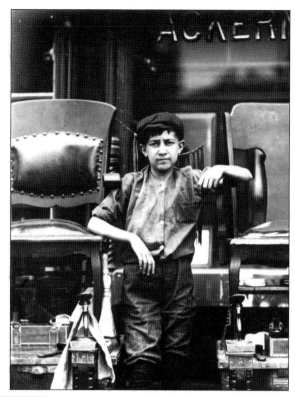

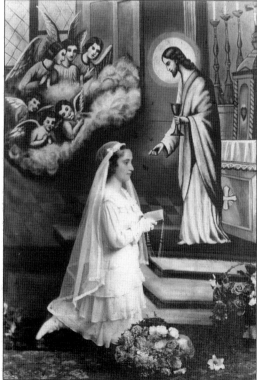

Adeline Campanella poses in 1933 in front of an elaborate trompe l'oeil background at the Copani Studio at 5 East Broadway on the occasion of her First Holy Communion, which she made at St. Joseph's Church on Monroe Street in Little Italy. The background features an image of Christ holding out a communion wafer and a cup of wine. (Lori Wallach.)

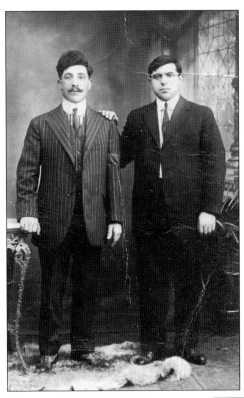

Rosario Campanella (born in 1885) poses on the left in this photograph taken in his hometown of Francavilla, Sicily, around 1909, the year he was married. By 1910, he had arrived in New York City and was working as a carpenter. In that year alone, 258,000 Italians immigrated to the United States. (Lori Wallach.)

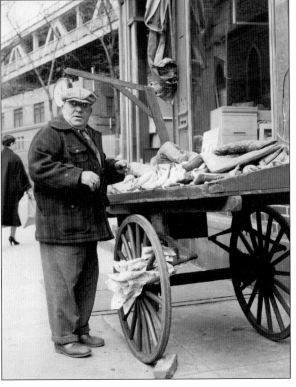

Italian immigrant Rosario Campanella stands next to his banana cart near the Manhattan Bridge during the 1930s. Note the sheets of newspaper in the spokes of the wheels; these were used to wrap bananas for the customers. Campanella lived nearby in a building on Henry Street, where he kept a supply of bananas in the basement. During World War II, he could no longer get banana shipments, so he opened a grocery store on the first floor of the building. (Lori Wallach.)

This confirmation certificate for Ella Barrett is dated April 21, 1931. Born of Irish parentage, she was confirmed at the Church of St. Thomas the Apostle, located at 262 West 118th Street. Built in 1907, the church was designed by the architect Thomas Henry Poole. (Christine Hillman.)

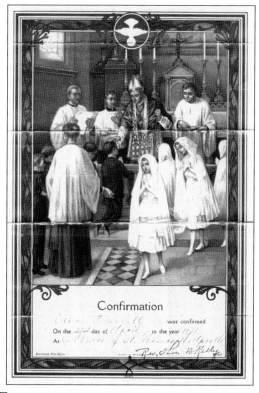

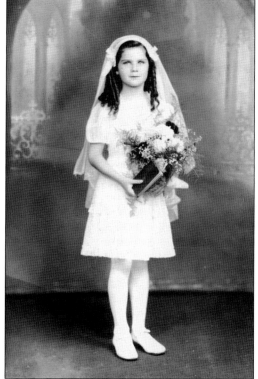

Ann Lappin poses on the occasion of her first communion in 1942. The event took place at St. Sebastian's Church in Woodside, where her family lived at the time. Ann was the third of six children; her younger siblings received their first communion at St. Mary's in Flushing, where the family moved. Ann was confirmed at St. Andrew's in Flushing. (Ann Gardenfeld.)

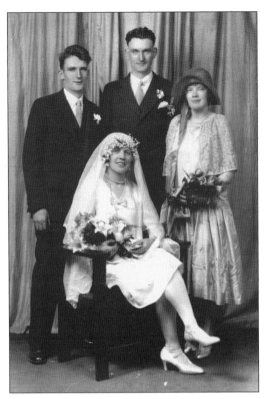

This is a wedding day photograph taken in April 1928. The bride is Elizabeth McPhillips. Standing behind her are, from left to right, the groom Peter Lappin, his brother Patrick Lappin, and the bride's sister Margaret McPhillips. The wedding took place at St. Catherine of Siena Church at 411 East 68th Street in Manhattan, where both families lived. After the wedding, the couple moved briefly to Brooklyn and then to Woodside, in the parish of St. Sebastian's. (Ann Gardenfeld.)

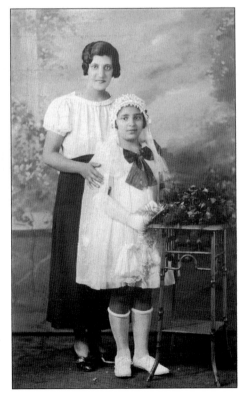

This is a communion photograph of Frances "Peggy" Tornese with her mother, Lucille Tornese, around 1934. They lived on Third Avenue near 104th Street in Manhattan. In the 1940s, Lucille was involved in the American Labor Party and worked for United States representative Vito Marcantonio. Later on, she remarried and as Lucille DeGeorge founded the American-Italian Women of Achievement. Peggy eventually married Alfred Biaggi, the brother of illustrious congressman and 1973 mayoral candidate Mario Biaggi. (Lori Wallach.)

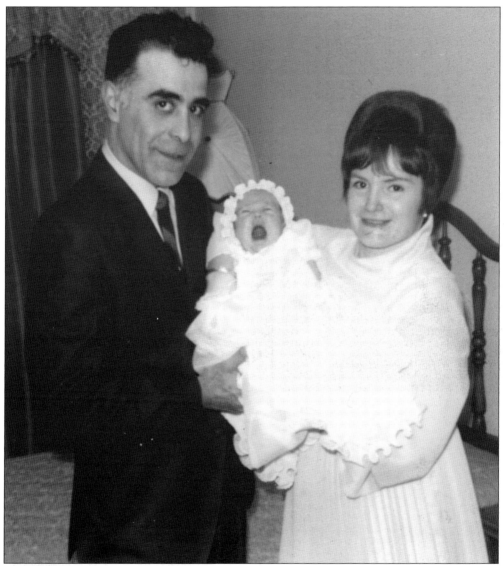

In this image, a crying baby Lisa Marie Lanteri is held by her godparents, Rosemarie and Angelo Bergamasco, at Lisa's home in Woodside, Queens, in May 1970. In Catholic life, the role of the godparents is taken very seriously. According to the code of canon law, godparents' role is "to present an infant at the baptism, and who will help the baptized to lead a Christian life in harmony with baptism, and to fulfill faithfully the obligations connected with it." Over the years, Rosemarie and Angelo, despite living in the Bronx, have always been present for the big events throughout Lisa's life, including graduations, birthdays, her wedding, and her children's christenings. Growing up with these positive role models, Lisa followed suit for the birth of her own daughter, naming her best and most trusted friend as her godmother. (Lisa Kelly.)

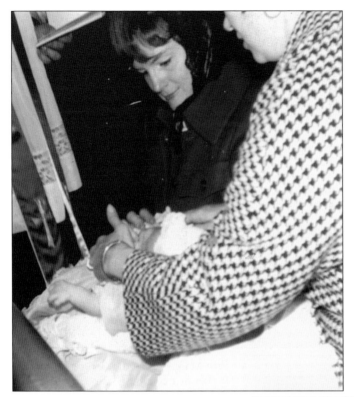

Of Swiss and Italian heritage, baby Lisa Marie Lanteri was christened in the Blessed Virgin Mary Help of Christians Church (founded 1854) in her hometown of Woodside, Queens, in May 1970 as her godmother and mother looked on. The water poured over the baby's head during baptism is symbolic of the original sin with which everyone is born being washed away. (Lisa Kelly.)

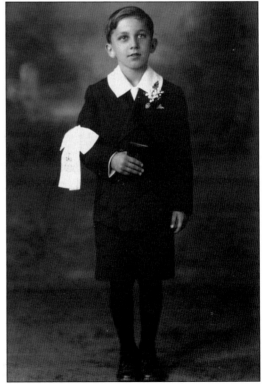

This communion photograph of a dapper Eugene Marciczkiewicz was taken in Goldstein's Studio in the Bronx in 1936. Marciczkiewicz, age nine, received his first communion at Our Lady of Victory Church, located at Webster Avenue and 171st Street in the Bronx. Marciczkiewicz was born in the Bronx of Polish immigrant parents. Since the late 19th century, Polish Catholics have been a major part of New York City's Catholic community, and several Polish churches were built in the city in response to the influx of Polish immigrants. (Patrick Wallach.)

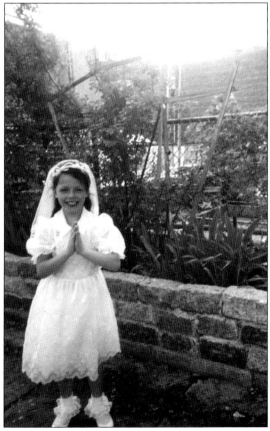

Erin Margaret Flynn, age seven, studies for her first communion in the spring of 1992. Erin, like thousands of other children making their first communion that year, worked hard to memorize the various spoken and sung portions of the ceremony. At left, she is shown posing on her way to the church that May day. Erin was born of an Irish father from County Limerick who had arrived in the United States just five years before her birth and a native New Yorker German Irish mother. Both of her parents actively encouraged their daughter during her second-grade year, as she carefully prepared to receive the sacrament. At the time, she lived in the Morris Park section of the Bronx and attended the Our Lady of Solace School, located on Morris Park Avenue in the Bronx and closed in 2006. Regis Philbin attended the school. The first communion took place in the neighboring Our Lady of Solace Church, which is next door to the site formerly occupied by the school. (Erin Margaret Flynn.)

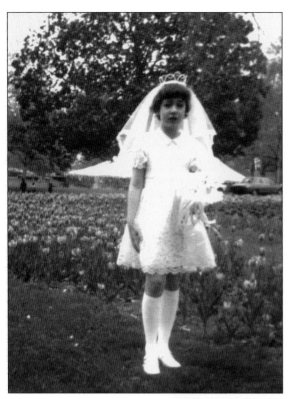

Lisa Marie Lanteri's first communion took place at her hometown church, Blessed Virgin Mary Help of Christians Church in Woodside, Queens, in May 1978. Following the communion, her parents and grandparents drove her up to the Bronx Botanical Gardens to take some photographs of Lisa in her communion dress in front of the garden's blossoming spring flowers. In the image at left, she poses in front of tulips. After that, they drove back to her home for a celebration, joined by her godparents and their family. In the image below, her mother presents her with a cake in honor of her making communion. (Lisa Kelly.)

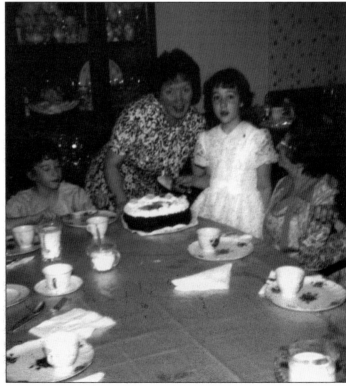

Ann Sheridan (left) and Jill Gardenfeld head down the aisle at St. Kevin's Church in Flushing, Queens, to receive their first communion in May 1977. Jill was the youngest of four sisters, all of whom received their first communion at St. Kevin's. Her parents took the family out for dinner at McElroy's Restaurant in Bayside to celebrate. (Ann and Michael Gardenfeld.)

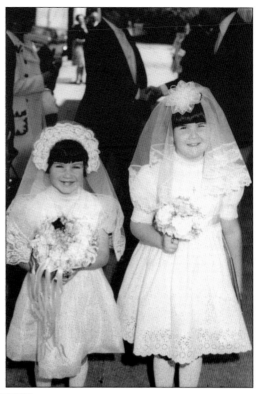

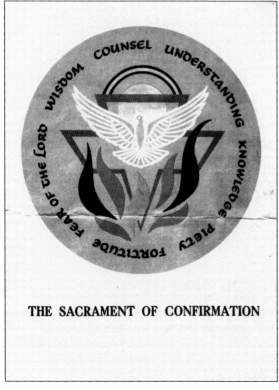

THE SACRAMENT OF CONFIRMATION

The sacrament of confirmation is explained in detail in this pamphlet published in 1965. The booklet contains the imprimatur, or official approval as to its religious content, of the then-archbishop of New York, Francis Cardinal Spellman. (Christine Hillman.)

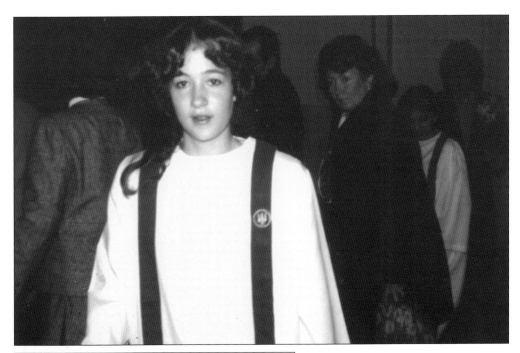

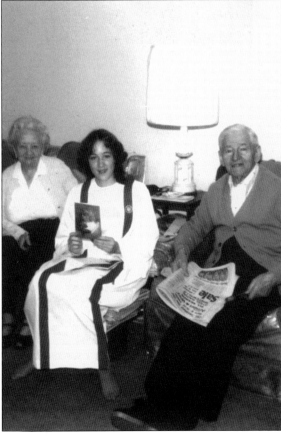

In the image above, an anticipation-filled 13-year-old Lisa Marie Lanteri files into her church pew, followed by her mother, just before her confirmation ceremony was about to begin in October 1983. The event took place at Blessed Virgin Mary Help of Christians Church in the Woodside section of Queens. For those Catholics such as Lisa who attended public school, their communion and confirmation would be achieved through special religious education classes (known as CCD, or Confraternity of Christian Doctrine). In the image at left, Lisa relaxes at home after she was confirmed. Sitting with her French Swiss grandparents Marie and François Quiquerez, Lisa proudly shows off the confirmation program. Switzerland has a mix of ethnic groups and religions, including French Catholics, Italian Catholics, and both German Catholics and Protestants. In 1888, the population of Switzerland was 71 percent German speaking, 21 percent French speaking, and 5 percent Italian speaking. (Lisa Kelly.)

This is a communion photograph of Vincent Sasso, taken in May 1966. Vincent, born in Queens of Italian American parents, received his first communion at St. Thomas the Apostle Church in Woodhaven, Queens. He was married in St. Kevin's Church in Flushing in 1989. (Ann and Michael Gardenfeld.)

Erin Margaret Flynn's confirmation took place in May 1997, while she was in seventh grade. A student at St. Theresa's School in the Pelham Bay section of the Bronx, she had transferred there in the sixth grade after her family moved to the Throgs Neck section. Her sponsor was her older sister Laurie. Erin is seen here at the party (given at her house) that followed the ceremony. Confirmation parties have long been a tradition among Catholics, who celebrate the special occasion by inviting family and friends. (Erin Margaret Flynn.)

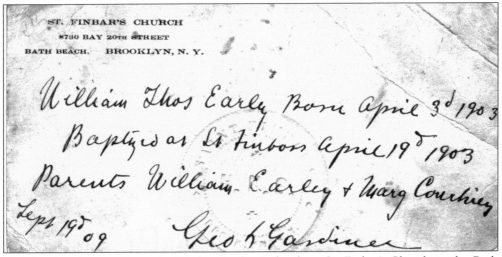

This is a baptism certificate for Gladys Cecilia Earley from St. Finbar's Church in the Bath Beach section of Brooklyn, dated 1909. It certifies that Gladys was baptized in January 1899. Such replacement certificates were often issued as early-20th-century families moved often and important papers were misplaced. (Jean Prommersberger.)

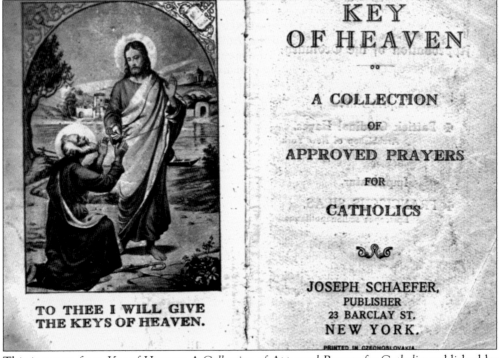

This is a page from *Key of Heaven: A Collection of Approved Prayers for Catholics* published by Joseph Schaefer of 23 Barclay Street in Manhattan in 1925. The book features the imprimatur of Patrick Cardinal Hayes and contains a variety of prayers for all occasions. Besides a Bible, most Catholic New York households were likely to have one or more additional Catholic-themed books. Other popular Catholic books of the late 19th and early 20th century were *Lives of the Saints, Garden of the Soul, Guide to Heaven, Treasury of Prayer, Way to Heaven,* and *Path to Paradise.* (Author's collection.)

Four

CHURCHES AND PLACES

Each of the hundreds of Catholic churches in New York City is but a single page in the incredible continuing story of the growth of Catholic dominance in New York City. From not a single church in 1784 to 176 churches just 100 years later, the Archdiocese of New York saw a dramatic increase. Similar growth was experienced by the Diocese of Brooklyn during the late 19th century. As the city's Catholic population exploded, existing parishes were carved into new ones. Each of the city's hundreds of Catholic churches is a unique place of worship, with its own distinct architecture, ensconced in its own distinct neighborhood, with its own distinct parishioners. Besides churches, there are other locales in the city that are closely associated with the story of New York's Catholics, and these are also shown in this chapter.

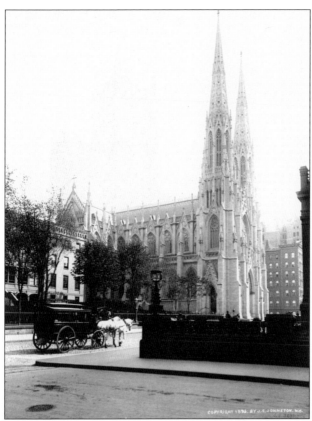

When originally built, St. Patrick's Cathedral was set against a relatively sparse background. By the time this photograph was taken in 1894, only 15 years after completion of the church, the surrounding neighborhood had already become a fashionable address.

The Church of the Nativity, located at 46–48 Second Avenue in Manhattan, was designed by Town, Davie and Dakin in the Greek Revival style and completed in 1833. In 1844, a mob of Know-Nothings (an anti-Catholic organization whose greatest fear was that the Catholics were obtaining too much power) arrived to burn the church but was repelled by a larger crowd of parishioners. The building is seen here in a 1967 photograph.

The Church of St. Paul the Apostle is located at 59th Street and Ninth Avenue. The parish was founded in 1858 and the cornerstone laid in 1876. The church is 284 feet long, 121 feet wide, and 114 feet high. The parish originally extended from 52nd Street to 110th Street, from the Hudson River to Sixth Avenue. This photograph dates from the 1960s.

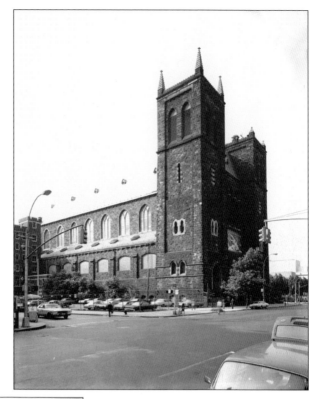

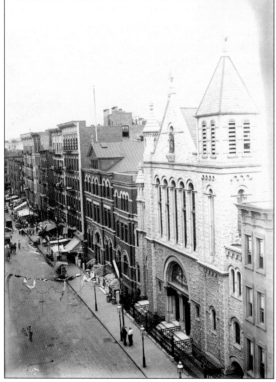

The Italian Our Lady of Mount Carmel parish was founded in 1881, when the first mass was said in a chapel at 111th Street. The cornerstone for the church was laid in 1884. The new church, located at 115th Street near the East River in East Harlem, was blessed by Archbishop Michael Corrigan, who sprinkled the walls with holy water. In 1927, the new bell tower was completed; this images dates from about 1910.

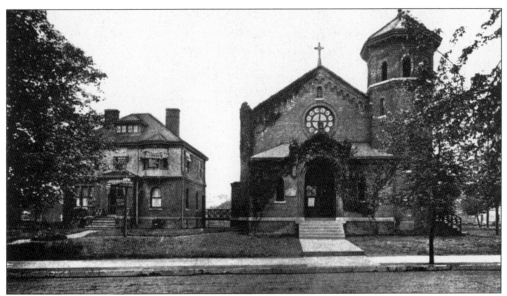

The Our Lady of Help of Christians Church was built in Tottenville, Staten Island, in 1898 to replace an earlier church built in 1890. By 1910, there were several Catholic churches in Staten Island neighborhoods, including Rosebank, Port Richmond, Tomkinsville, New Brighton, Stapleton, and Linoleumville.

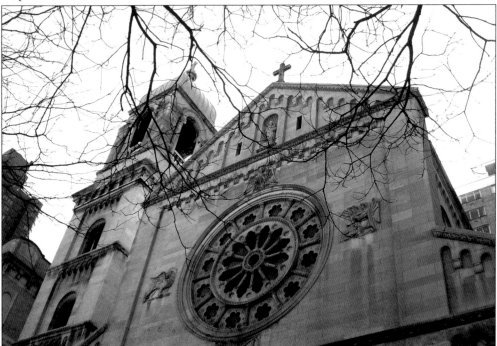

The St. Joseph's parish (Catholic) was founded in 1873 and catered to mainly German parishioners. The first church was built in 1874, and when the parish outgrew its home, a new church was built in 1894. The majestic building still stands today at 404 East 87th Street, although there are few German parishioners left. Pope Benedict XVI visited St. Joseph's in April 2008. (Author's collection.)

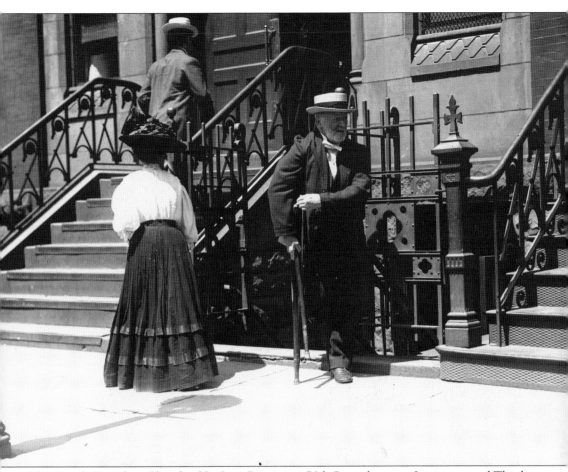

The French Canadian Church of St. Jean Baptiste at 76th Street between Lexington and Third Avenues has a relic of St. Anne, the mother of St. Mary. The relic, a portion of arm bone, was sent by Pope Leo XIII in 1892 to North America, destined for the St. Anne De Beaupre Church in Quebec. En route to Quebec, Rev. J. C. Marquis of Canada arrived at the rectory of St. Jean's on May 1, 1892, and asked that the relic be displayed. Huge crowds turned out to pray at the relic, and two months later the original relic was divided and a piece was sent back to New York for permanent display. Novena services are held every year during the week before the feast of St. Anne in July. According to legend, the relics of St. Anne were originally brought from the Holy Land to Constantinople in the year 710. In this image from about 1910, a man heads to pray before the St. Anne relic.

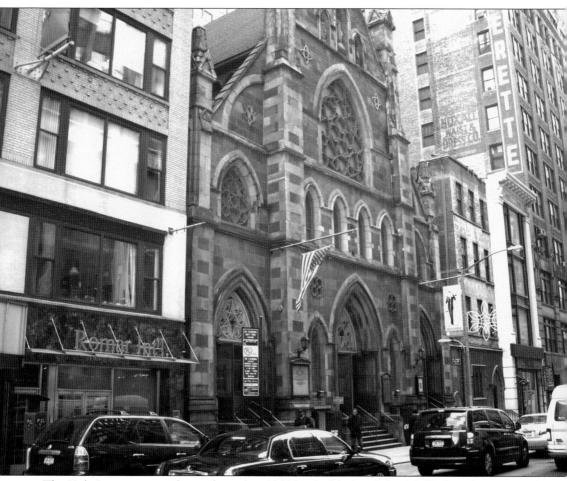

The Holy Innocents parish was formed in 1866 by Archbishop John McCloskey, from parts of other existing parishes (St. Stephen's, St. Michael's, Holy Cross, Cathedral, and St. Columba's). Rev. John Larkin, a native of County Galway in Ireland, was the first pastor. He purchased property at the corner of 37th Street and Broadway, upon which a small Episcopal church stood. This building was used as a chapel during construction of Holy Innocents. The cornerstone of the new church was laid in 1869, and the church was dedicated in 1870. A school was built in 1872. The two buildings and the site cost a total of $306,000, some of which was donated by Eugene Kelly and the Iselin and Havemeyer families. In 1901, $50,000 in improvements were made to the church. All the debts were paid off and the church consecrated in 1910 by Archbishop Michael Corrigan. (Author's collection.)

The Church of St. John the Baptist is located on West 30th Street, just a block away from the St. Francis of Assisi Church. It was first built in 1840. A fire in 1997 destroyed the organ and damaged the church, which was reconstructed soon after. The modern side of the church complex (facing 31st Street near Seventh Avenue), shown here, is what is seen by thousands of Penn Station commuters every day. (Author's collection.)

The Our Lady of Hope parish was founded in Middle Village in 1960. The church was built in the early 1980s on 71st Street and features a distinctive stone-face exterior and a tall bell tower. A school was also opened in the parish. Our Lady of Hope was the second Catholic church in Middle Village. The first, St. Margaret's, was originally built in 1860 and was subsequently rebuilt in 1902 and 1935. (Lisa Kelly.)

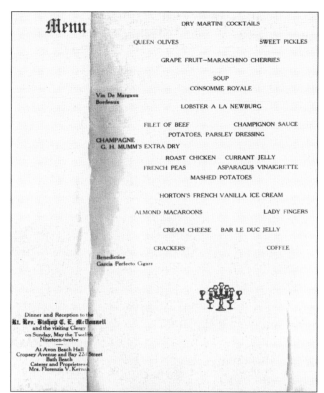

Menu

DRY MARTINI COCKTAILS

QUEEN OLIVES SWEET PICKLES

GRAPE FRUIT—MARASCHINO CHERRIES

SOUP

CONSOMME ROYALE

Vin De Margaux
Bordeaux

LOBSTER A LA NEWBURG

FILET OF BEEF CHAMPIGNON SAUCE

POTATOES, PARSLEY DRESSING

CHAMPAGNE
G. H. MUMM'S EXTRA DRY

ROAST CHICKEN CURRANT JELLY

FRENCH PEAS ASPARAGUS VINAIGRETTE

MASHED POTATOES

HORTON'S FRENCH VANILLA ICE CREAM

ALMOND MACAROONS LADY FINGERS

CREAM CHEESE BAR LE DUC JELLY

CRACKERS COFFEE

Benedictine
Garcia Perfecto Cigars

Dinner and Reception to the
Rt. Rev. Bishop C. E. McDonnell
and the visiting Clergy
on Sunday, May the Twelfth
Nineteen-twelve

At Avon Beach Hall
Cropsey Avenue and Bay 22d Street
Bath Beach
Caterer and Proprietress
Mrs. Florenzia V. Kernan

In May 1912, a dinner was held in honor of the dedication of the new St. Finbar's Church in the Bath Beach section of Brooklyn. The dinner was held at the Avon Beach Hall on Cropsey Avenue and included a menu of fine foods such as lobster, filet of beef, champagne, and asparagus. (Jean Prommersberger.)

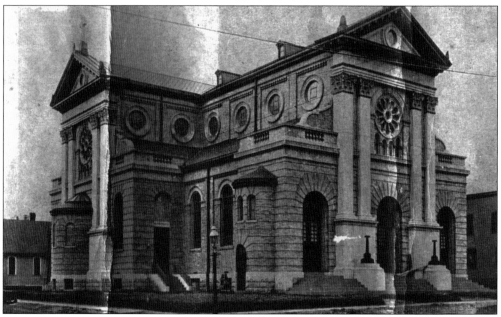

This is the newly completed St. Finbar's Church in the Bath Beach section of Brooklyn, as it appeared soon after its completion in 1912. The new building replaced a much smaller existing structure. It was common during the early 20th century for parishes to need larger buildings as the number of parishioners rose dramatically due to an influx of Catholic immigrants to New York City. (Jean Prommersberger.)

The St. Teresa Church at Henry and Rutgers Streets in Manhattan was built in 1843 as a Presbyterian church. When the Presbyterian occupants moved uptown, the church became Roman Catholic. This photograph of the church was taken in March 1936. The first pastor, Fr. James Boyce, established a boys' school in 1865 and called upon the Ursuline Sisters to establish a girls' school in 1872.

Located less than a block from Penn Station, the popular St. Francis of Assisi Church (off Seventh Avenue on 31st Street) is frequented by numerous tourists as well as many Catholics who work in the vicinity. The first church on the site was built in 1844 at the insistence of Fr. Zachary Kunz, a Hungarian Franciscan priest. When more space was needed, the current church was built in 1892. The church offers free food for the hungry and homeless every day, a tradition dating back to the 1930s. (Author's collection.)

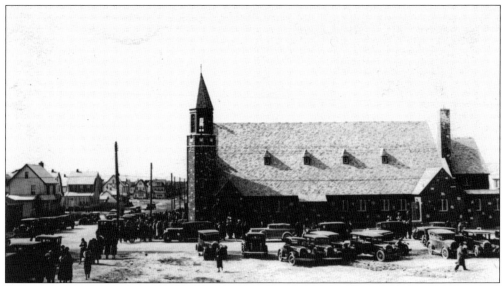

When German immigrant Carl Prommersberger and his family moved from Ridgewood, Queens, to Hollis, Queens, in the early 1930s, they attended St. Pascal of Baylis Church (seen here in 1932), located at 113th Avenue and 199th Street. They also lived for about eight years in the rooms on the second floor of a home above the St. Pascal Parish Hall. (Prommersberger family.)

The Ascension Church, located south of Queens Boulevard at 86–13 55th Avenue in Elmhurst, Queens, was built during the mid-20th century and has for decades been serving the needs of the eclectic population of Elmhurst. The neighborhood is filled with a mixture of single-family homes, apartments, and multifamily attached homes and is one of the most ethnically diverse communities. (Author's collection.)

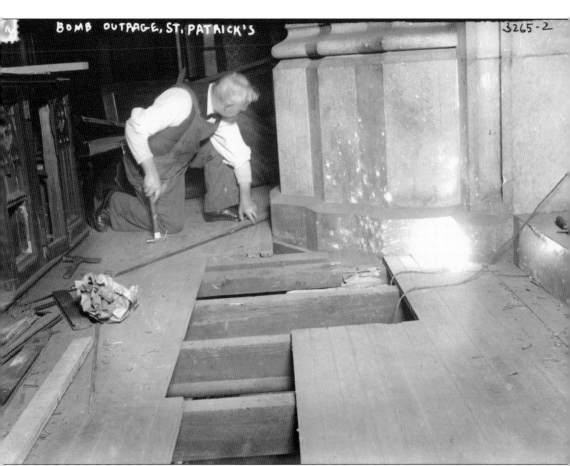

On October 13, 1913, at a little past 3:00 in the afternoon, a man set off a powerful bomb in the nave of St. Patrick's Cathedral, at the base of a stone column. Two people were slightly injured, and the windows of the rectory were broken. The suspect was seen entering the cathedral 10 minutes before the bomb exploded and leaving a few minutes later. Another bomb, placed by the same person, had been exploded in St. Alphonsus Church on West Broadway earlier in the day. The bombs were called "crude affairs" but were described as nonetheless powerful enough to destroy a building if properly placed. The city in those days was particularly plagued by bombs placed by anarchists and others; there were 55 bomb explosions in the city during the first 10 months of 1914. This image shows repairs under way at the cathedral, where the bomb caused over $1,000 in damage.

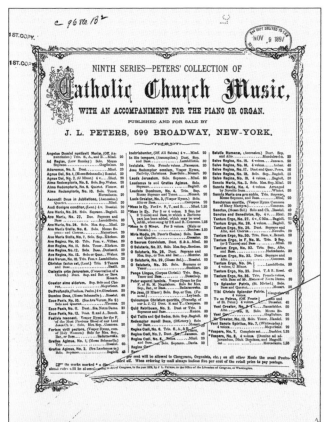

This advertisement dates from 1870 and proclaims the wide array of available Latin-language music for Catholic churches published by J. L. Peters of 599 Broadway. A fine church organ is often one of the most sought-after additions to any church. For many Catholics, the sound of the pipes hitting the joyful notes of celebratory hymns is one of the highlights of the churchgoing experience.

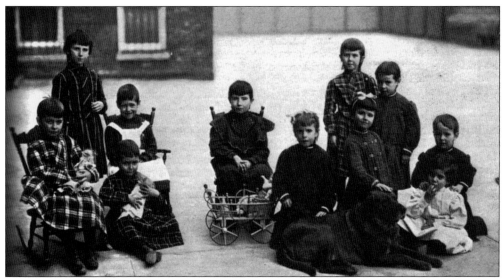

The Sisters of Mercy came to Brooklyn in 1855 and occupied a small convent on Jay Street. A new, larger convent was built in 1862 on Willoughby Avenue. The St. Francis Convent had 150 orphans. The Angel Guardian Home on Twelfth Avenue in Brooklyn had about 300 young children. The sisters also had a Home for Infants in Brooklyn and a country home and farm in Syosset, Long Island. (Author's collection.)

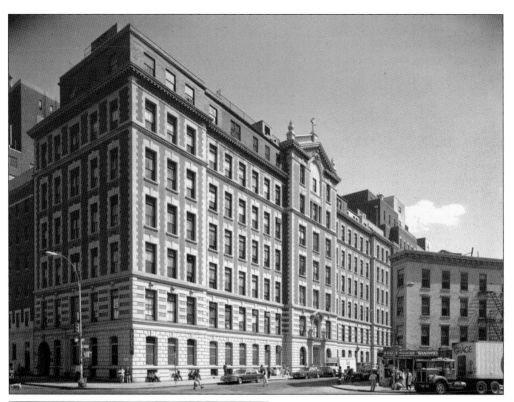

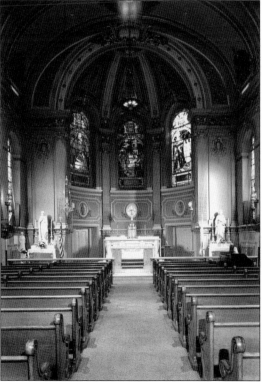

The Elizabeth Bayley Seton Building
(151–167 West 11th Street) was part of
the St. Vincent's Hospital complex in
Manhattan. St. Vincent's Hospital was
founded in 1849 by the Sisters of Charity
of St. Vincent de Paul. It was the first
Catholic hospital in New York City.
This building, named after the first
American-born saint (1774–1821), was
built in 1897. It was designed by William
Schickel and Isaac P. Ditmars, well-known
designers of Catholic buildings, but
demolished in 1984 to make way for a new
structure. These images show the exterior
of the building seen at West 11th Street
and Seventh Avenue and an interior shot
of the chapel.

The St. Cecilia's Maternity Hospital was located at Richardson and Humboldt Streets in Brooklyn. It had about 50 beds and 50 bassinets and a staff of about 25 people. Seen here in 1930, it was later known as the St. Catherine's Maternity Hospital. (Prommersberger family.)

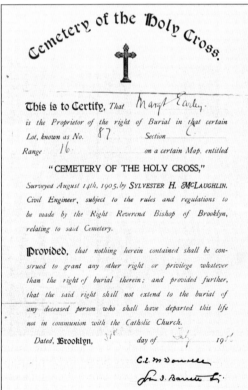

In July 1906, 41-year-old Margaret Earley, then living in Nassau County, purchased a plot at the Holy Cross Cemetery in Brooklyn. The Roman Catholic cemetery was founded in 1849, and its main entrance is on Brooklyn Avenue at Tilden Avenue. The Diocese of Brooklyn currently operates nine cemeteries. (Jean Prommersberger.)

A statue of Joan of Arc on a horse is located at Riverside Drive and 93rd Street in Manhattan. Designed by Anna Vaughn Hyatt Huntington (with a base designed by architect John V. Van Pelt), the statue was completed in 1915 to commemorate the belated 500th anniversary of the saint's birth in 1911. It was the first sculpture in New York City to memorialize a woman. The sculpture was dedicated on December 6, 1915, and was donated by the Joan of Arc Statue Committee.

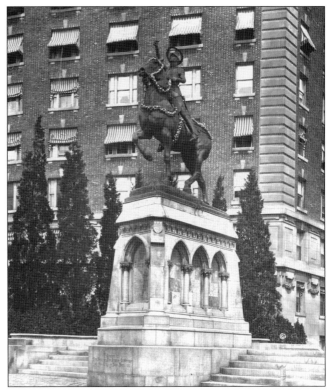

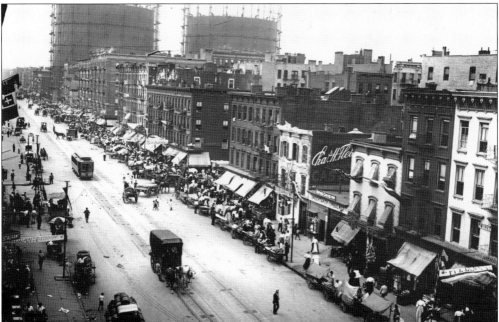

By 1910, the number of Italians and their children living in New York City equaled the entire population of the city of Rome. In Little Italy, centered around Mulberry Street in Manhattan, for blocks, the neighborhood was filled with Italian signs: Italian grocery stores, Italian banks, and Italian churches.

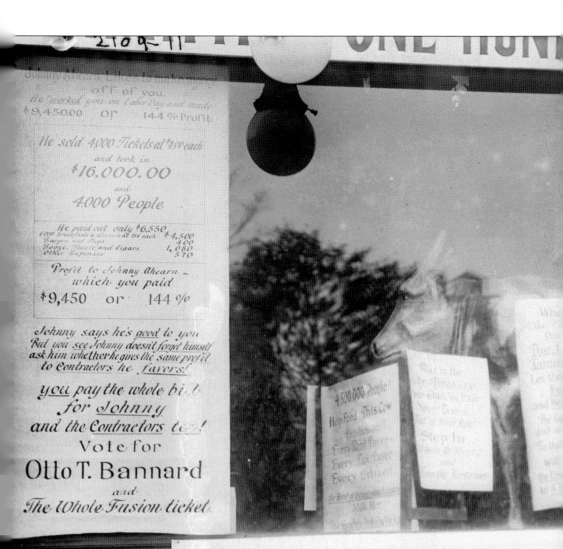

This image shows political signs in the window of the Democratic Party headquarters, Tammany Hall, around 1910. For decades in the late 19th and early 20th centuries, the powerful Tammany Hall political machine was largely controlled by Irish Catholics. Political mass meetings commonly took place in the Tammany Hall building, including glamorous public meetings, filled with pomp and circumstance; however, the true nitty gritty work of the Democratic Party in New York City often took place within the individual wards, or political districts of the city, where party bosses consolidated their power and brokered deals.

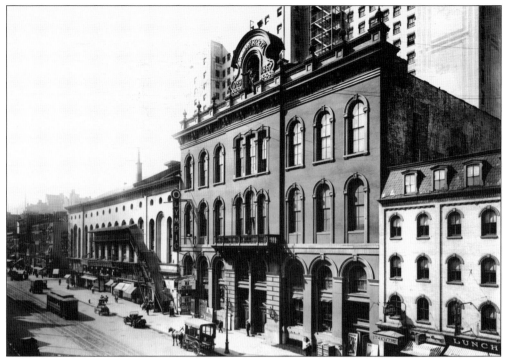

Tammany Hall, headquarters of the New York City Democratic Party, was located near Union Square at East 14th Street between Third Avenue and Irving Place. It is seen here in a photograph from the early 20th century. In 1929, Tammany headquarters moved to a new structure at 17th Street and Union Square East.

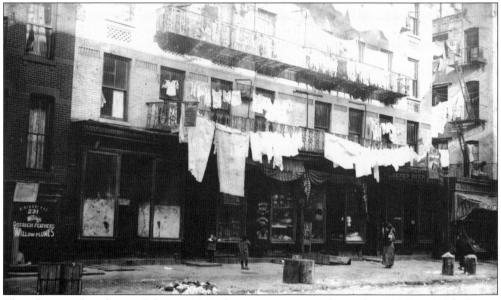

This photograph, taken in February 1912, shows an apartment located at 233 East 107th Street. A rental sign reads, "Eleganti Apartmenti," catering to the Italian population living in the neighborhood at the time. At the time of the photograph, the apartment license had recently been revoked. There were eight families living there under miserable conditions, doing home work.

Five

EDUCATION

For more than 200 years, Catholic education has been an integral part of New York City Catholic life. From its humble beginnings in 1805 with just a handful of students in St. Peter's parish school in Manhattan, Catholic education soon blossomed as Irish, German, then Italian, Polish, and other European Catholic immigration increased as the 19th century progressed. Many schools were also constructed in the outer boroughs. The first school in what are now the other four boroughs was opened in Brooklyn in 1823, connected with St. James Church. By the late 19th century, new churches were being built throughout the city at a rapid pace, and brand-new schools often accompanied these nascent parishes. At the country's peak of Catholic education in 1965, there were 12,000 Catholic schools in the country; about 2,000 schools have closed nationwide since 1990. Although the city has also experienced its share of recent closings and consolidations, Catholic education is still a powerful force in New York. The city's Catholic schools currently serve more than 88,000 students.

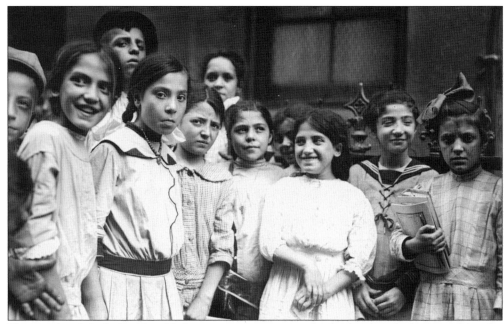

Thousands of Catholic New Yorkers were sent to parochial schools, which opened by the dozen as more and more Catholic immigrants arrived in the country at the beginning of the 20th century. But unlike public school, parochial school cost money, so not everyone who wanted to send their children could afford to. This image shows a group of Italian public school children in Manhattan, during the early 20th century.

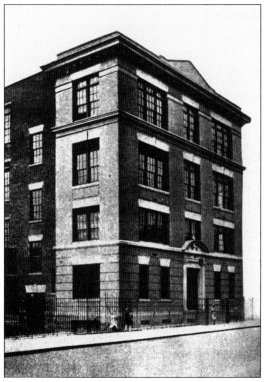

The brick School of St. Anselm, at 151st Street near Robbins Avenue in the Bronx, was built in 1908. It followed the church, which was completed in 1893 and dedicated by Archbishop Michael Corrigan. In 1914, there were 355 boys and 360 girls enrolled, taught by 15 Dominican Sisters. (Author's collection.)

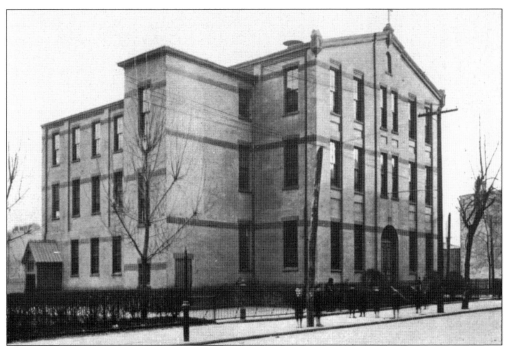

The St. Teresa School, located near Classon Avenue and Butler Street in Brooklyn, was opened in September 1883 by Fr. Joseph McNamee, who had organized the parish in 1874. The 50-by-90-foot school was run by 13 Sisters of St. Joseph. In 1914, there were 548 boys and 562 girls registered and a total of 25 teachers. In 1905, Father McNamee added two impressive towers to the church for a height of 157 feet. (Author's collection.)

The parish of St. Anthony of Padua in the Bronx was established in 1903 for the extensive local German population. In May 1904, a church, school, and residence were begun. The building was completed a year later. In 1914, there were 430 pupils enrolled. The basement was used as a hall, the first floor as a church, the second floor for classrooms, and the third floor for classrooms and sisters' residence. (Author's collection.)

This photograph shows fourth-grade class 4A at St. Kevin's School in Flushing, Queens. The picture was taken in November 1946. The peak of Catholic school attendance in New York City occurred during the middle of the 20th century as the children and grandchildren of immigrants filled parochial schools. (Ann and Michael Gardenfeld.)

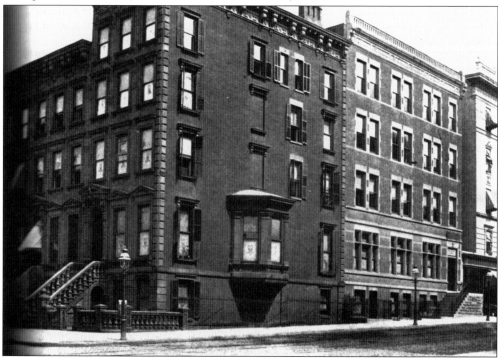

The Villa Maria Academy at 139 East 79th Street was opened in 1886. In 1914, there were 200 pupils, all girls. The school was conducted by the sisters of the Congregation of Notre Dame and run under the auspices of the French Canadian congregation of the Most Blessed Sacrament. (Author's collection.)

The Ascension School, on 53rd Avenue in Elmhurst, was closed in 2005 after more than 50 years of service to the community. The school population was merged with St. Adalbert's School, also in Elmhurst. Ascension was one of 26 Catholic schools that the Brooklyn diocese announced in February 2005 would close in June 2005. Following its closing, the building was used as an annex for the burgeoning population of nearby Public School 102. (Author's collection.)

This image shows the convent at the Ascension School in Elmhurst, Queens, around 1957. Like many other convents in New York City, this one, located on Seabury Street, was eventually not needed as the number of nuns in residence declined. The property was eventually sold and is now a private residence. (Author's collection.)

This image shows the former convent of the Ascension School in Elmhurst, Queens, as it appeared in 2008, many years after it had been converted to a private residence. When a diocesan property is no longer used, the diocese has to make a decision as to the future use of the property. (Author's collection.)

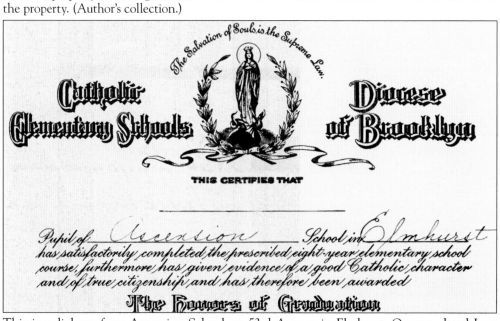

This is a diploma from Ascension School on 53rd Avenue in Elmhurst, Queens, dated June 1961. The Ascension School was built in the 1950s and served the community for many years before it closed in 2005 and was merged with nearby St. Adalbert's. As in all neighborhoods with Catholic schools, it was a common sight to see groups of distinctly uniformed schoolchildren walking to and from school. (Author's collection.)

Catholic high schools offer sports programs comparable to secular high schools. In this image from the 1940s, the Brooklyn Preparatory (a Catholic Jesuit high school founded in 1908 in the Crown Heights section of Brooklyn) football team plays against Chaminade High School in Mineola. Chaminade won 13-7 in front of a crowd of 4,500 spectators. (Jean Prommersberger.)

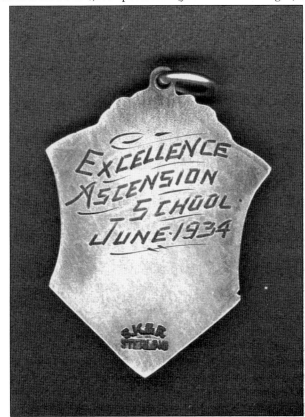

This medal was given by the Ascension School (220 West 108th Street, between Broadway and Amsterdam Avenue in Manhattan) to a star pupil in 1934. The school was founded in 1911, under the supervision of the Sisters of Charity of Mount St. Vincent and the De La Salle Brothers. (Christine Hillman.)

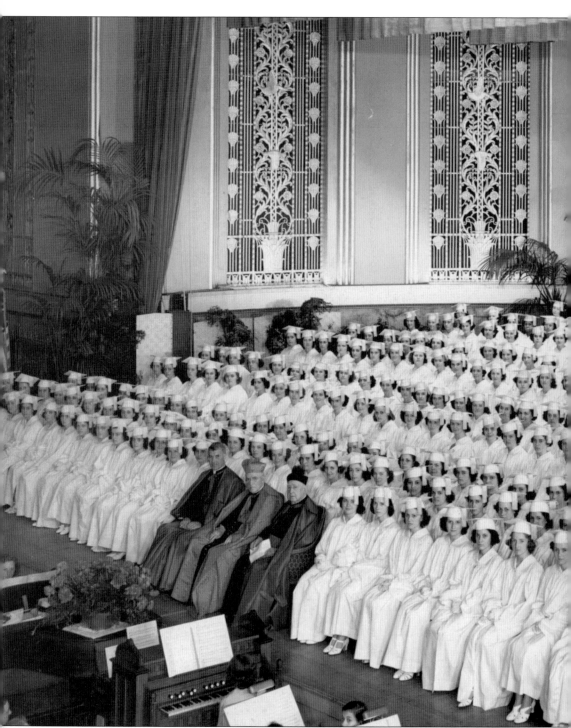

The all-girls Cathedral High School (located at 350 East 56th Street) graduating class of 1938 is seen here in its entirety, gathered at the recently constructed Waldorf-Astoria Hotel (Park Avenue between 49th and 50th Streets) on June 10, 1938. The college preparatory school's event was honored by the presence of the archbishop of New York, Patrick Cardinal Hayes (seated

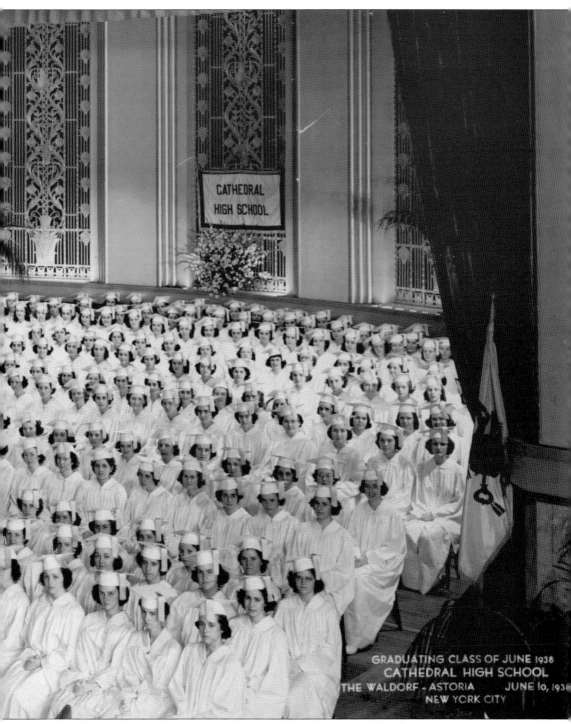

GRADUATING CLASS OF JUNE 1938
CATHEDRAL HIGH SCHOOL
THE WALDORF - ASTORIA JUNE 10, 1938
NEW YORK CITY

in the middle of the front row), seen here just a few months before his death. Cathedral High School began in 1905 with just two teachers and 28 students; by the 1950s, there were more than 800 students in the graduating class every year. More than 35,000 women have been educated at Cathedral High School since its opening. (Christine Hillman.)

The Our Lady of Hope School in Middle Village holds a highly successful annual Supermarket Bingo fund-raiser in the school gymnasium/cafeteria. Weeks before the event takes place, a committee of school parents solicits various neighborhood businesses for some sort of donations (merchandise or gift certificates) that are then used to create attractive gift baskets for use in the raffle drawings that evening. All kids in the school donate groceries for this special version of bingo (each grade bringing in a specific type of grocery item), which are then bagged in large brown grocery bags and given as prizes in the night's bingo contests. Winners are given little brown lunch bags, which are then traded in at the end of the evening for the filled large grocery bags. People who attend are invited to bring their own food and drink and have dinner during the event. Shown here is a scene from the January 2009 Supermarket Bingo event. (Lisa Kelly.)

Bronx native Christine Hillman, age six, played the Virgin Mary in her school's Christmas pageant in December 1979. It is a long-standing tradition for Catholic schools and churches to put on Christmas pageants in which the story of Jesus's birth is told in play format through the use of children acting out the different parts. Every year in New York, countless children are excited to play Mary, Joseph, the wise men, and other coveted roles in the numerous Christmas pageants that are put on. (Christine Hillman.)

The groundbreaking ceremony for the St. Theresa's School in the Pelham Bay section of the Bronx was held in October 1953 and the cornerstone laid in December 1954. A temporary school was opened in September 1954, and then the new school was opened in September 1955. This image shows Erin Margaret Flynn's eighth-grade graduation from St. Theresa's School, which took place in St. Theresa's Church in June 1998, across the street from the school. Erin is seated in the first row at left. The graduation ceremony was followed by a party at Erin's house, attended by both friends and family. Erin was very excited because she would soon be starting at the all-girls Preston High School, on Schurz Avenue in the Throgs Neck section of the Bronx, overlooking the East River. (Erin Margaret Flynn.)

In 1996, Bronx native Erin Margaret Flynn proudly stood in front of a quilt with family names that she and her classmates made in the sixth grade while attending St. Theresa's School, which went from kindergarten through eighth grade. The school is located on St. Theresa Avenue in Pelham Bay section of the Bronx. (Erin Margaret Flynn.)

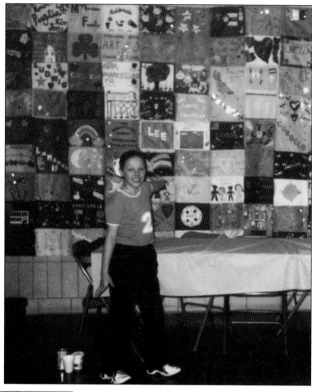

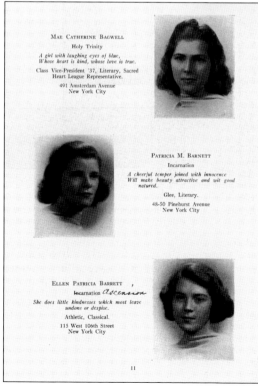

MAE CATHERINE BAGWELL
Holy Trinity
A girl with laughing eyes of blue,
Whose heart is kind, whose love is true.
Class Vice-President '37, Literary, Sacred Heart League Representative.
491 Amsterdam Avenue
New York City

PATRICIA M. BARNETT
Incarnation
A cheerful temper joined with innocence
Will make beauty attractive and wit good
natured.
Glee, Literary.
48-50 Pinehurst Avenue
New York City

ELLEN PATRICIA BARRETT ,
Incarnation *Ascension*
She does little kindnesses which most leave
undone or despise.
Athletic, Classical.
115 West 106th Street
New York City

11

This image is a page from the Cathedral High School (Archbishop Hughes Memorial) yearbook *The Spires*, so named after the spires of St. Patrick's Cathedral. The June 1938 yearbook was dedicated to Patrick Cardinal Hayes and featured a poem for him: "Twin towers to the heav'ns aspire, deep-shaken by a bold desire to reach the sky. Far beneath their noble height a red-robed figure wrapped in light of God's own grace kneels in prayer. Our Shepherd he, Cardinal of Charity!" (Christine Hillman.)

GREETING

My dear Graduates:

Heartiest congratulations to you, my dear young ladies of the Class of June, 1938. Another milestone in your lives has been reached. For the past four years, you have been praying and studying within these hallowed walls of Cathedral High School. Instructed and guided by the efficient and saintly daughters of Mother Seton, you have acquired much for the intellectual growth of your lives and you have been given a religious foundation that cannot but be your consolation and support in the great battle of life.

Well done! The felicitations of us all go out to you on this "Your Day" of triumph. You have the prayers and good wishes of all—of your parents who now see the reward of their anxieties and sacrifices;—of the members of the faculty who are now well repaid for their labor and zeal.

The future is now hidden from your eyes. Joy and sorrow, health and sickness, success and failure, are elements mingled in every life and consequently, are to be expected in your own. Devotion to your Catholic Ideal will be your mainstay so that as the years roll by you will always be strong in the hope that your Faith holds out to you and happy in the thought that you are children of Mary who will always keep the mantle of her love about you.

Thrice honored are you today by the presence of His Eminence our Cardinal and Archbishop. How happy he must be as he reviews the past years, recalling the anxiety, the planning, the sacrifice, all of which were so very necessary if this ambition of his heart, the erection and maintenance of Cathedral High School, were to be as it now is—a living reality—a glory to the Church of New York—a fitting monument to the memory of Archbishop Hughes who just one hundred years ago was consecrated Bishop of New York.

(Rev.) Matthew A. Delaney.

This is the message to the graduating class of 1938 at Cathedral High School, appearing in the yearbook. Cathedral High School had numerous clubs and activities for the girls, including the literary club, Aeneadae, Le Cercle Bernardette Soubirons, Catholic Action, Nieuwland Club, mathematics club, St. Genesius Dramatic Club, art club, history club, Hughesian Debating Council, athletic club, and Ambrosian Club. (Christine Hillman.)

Fordham University

NEW YORK CITY

Founded in 1841 Conducted by the Jesuits

AT FORDHAM ROAD, BRONX, NEW YORK 58, N. Y.

Fordham College, Boarding and Day School on Seventy Acre Campus
Fordham College, Evening Division
School of Business, Evening Session Only
College of Pharmacy
Graduate School of Arts and Sciences

AT 302 BROADWAY, NEW YORK 7, N. Y.

School of Education
School of Law

AT 134 EAST 39TH ST., NEW YORK 16, N. Y.

School of Social Service

Four Residence Halls for Men: St. John's Hall; Bishops' Hall
St. Robert's Hall; Dealy Hall

One Residence Hall for Religious Women: St. Mary's Hall

Fordham University was founded in 1841 by John Hughes, bishop of New York, as St. John's College. A charter was granted to this independent university in the Jesuit tradition in 1846, and the name was changed to Fordham in 1907. The university was originally located outside the city limits, before the Bronx became part of New York City. Shown here is an advertisement from the mid-1940s. (Jean Prommersberger.)

Richard Charles Hillman, of German and Irish descent, graduated from the St. Anthony School (elementary) in the Bronx in June 1960. His certificate is shown in the image at right. His brother Robert Hillman, whose certificate is shown below, graduated from kindergarten there in June 1956. The years that these brothers were in school were the peak years for parochial school attendance around the country. New York City Catholic schools have to follow a course of study prescribed and approved by the archdiocese as well as meet all the requirements of the New York State Education Department. (Christine Hillman.)

Manhattan College was established in 1853 by five Brothers. Overlooking Van Cortlandt Park in Riverdale (the Bronx), Manhattan College is an independent Catholic institution of higher learning. It was founded in the educational tradition of John Baptist De La Salle, the patron saint of teachers. At first it focused on arts and sciences, but in 1887, it added civil engineering to the course of study. Shown here is an advertisement for Manhattan College dating from the mid-1940s. (Jean Prommersberger.)

St. John's University was founded in 1870 by the Vincentian community. There are currently nearly 12,000 full-time undergraduate students and 5,000 graduate students enrolled. Famous alumni include former New York governors Mario Cuomo and Hugh Carey, as well as police commissioner Raymond Kelly. The Queens campus is on a 105-acre plot of land. This advertisement is from the 1940s. (Jean Prommersberger.)

Six

EVENTS AND CELEBRATIONS

The history of Catholic New York City is filled with wonderful celebrations of all types. Some of these events, such as St. Patrick's Day, Easter, and Christmas, are annual holidays that are celebrated in New York City on a grand and universal scale. Other events are special occasions, such as the 100-year anniversary of the founding of the Diocese of New York, funerals of Catholic notables, or visits from popes and other dignitaries. No matter what the occasion, all the events depicted in this chapter have one thing in common; they all brought together New York's Catholics as one unified group of people, united by a common religious heritage.

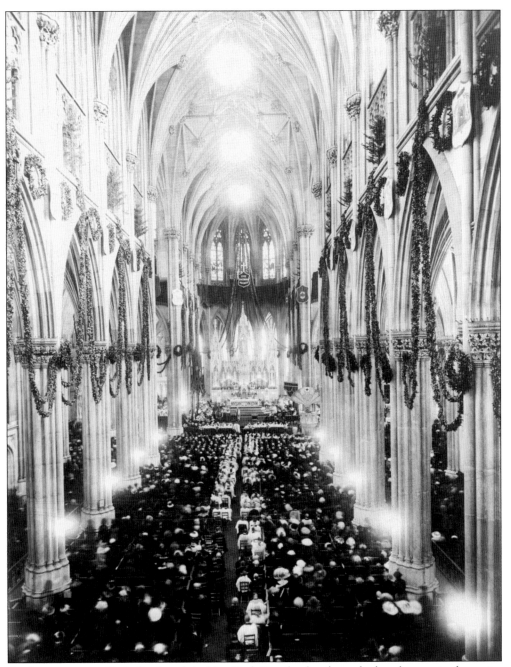

As the preeminent Catholic church in New York City (and perhaps the best known in the entire country), St. Patrick's Cathedral is especially popular with tourists and visitors on holidays. At the time of its construction, the cathedral's location on Fifth Avenue was somewhat distant from the central part of the city, which was many blocks south; but by the early 20th century, the location had become one of the most pivotal and popular points in the entire city. After the construction of Rockefeller Center nearby, the area continued to see an increase in tourism. In this image taken in December 1911, the decorated interior of the cathedral is shown.

Bobby Mutke (right) poses with Irma and Peter Prommersberger at the Prommersberger household at Christmastime 1939 in Queens. While nearly all Italian and Irish immigrants to New York City were Catholic, German immigrants were a mixture of Catholic and Protestant. (Prommersberger family.)

Born in Bavaria, illustrator Thomas Nast came to New York in 1846. Nast was famous for two things: for his drawings that brought the scandals of the corrupt William "Boss" Tweed to light and for his revolutionary drawings of Santa Claus. With his first illustration of Santa in 1863, Nast was responsible for creating the modern image of Santa. Shown here is an 1892 Nast drawing of Santa being hugged by a child.

This photograph shows a group of German friends celebrating the New Year's Eve holiday in an apartment in Queens in December 1931. They were gathered not just for New Year's Eve but also to celebrate the feast day of St. Sylvester (who was pope from 313 to 335), a celebration particular to German Catholics. (Prommersberger family.)

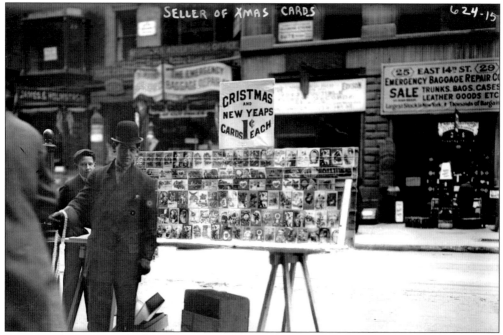

A young Christmas card seller awaits customers as he hawks his wares on East 14th Street in this photograph from the first decade of the 20th century. Christmas cards first became popular in the mid-19th century and since then have sold billions. Before 1875, Christmas cards were made in Europe, not the United States. Note the vendor has misspelled Christmas on his sign.

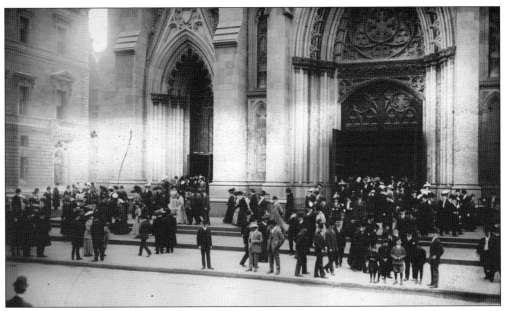

The celebrated St. Patrick's Cathedral is in its full glory during Christmas and Easter. The Palm Sunday and Easter celebrations are especially popular. Recent Easter mass schedules have included a Saturday vigil at 8:00 p.m., and then Sunday masses at 7:00 a.m., 8:00 a.m., 8:45 a.m., 10:15 a.m. (tickets required), noon, 1:00 p.m., and 5:30 p.m. These masses have been popular since the cathedral first opened. In 1911, for example, 4,500 people attended the 11:00 a.m. mass with tickets. A thousand others were turned away. These two images show people leaving St. Patrick's after Easter services in 1908 and 1911.

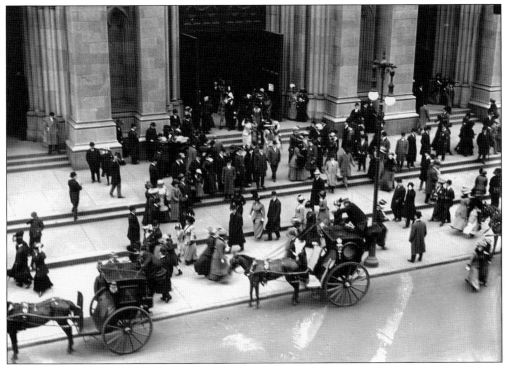

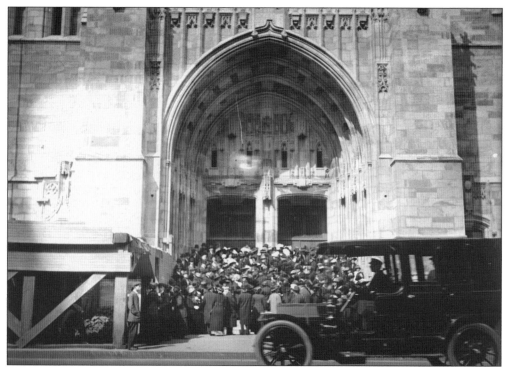

More than any other Sunday of the year, during Easter in New York the city is abuzz with activity, not just today, but for hundreds of years. These images show a crowd at St. Patrick's on Easter Day in 1913 and a crowd in front of the cathedral on Easter in 1914. In 1913, huge crowds turned out to see Cardinal John M. Farley say mass; 2,000 people were turned away. That Easter, the cardinal's procession into the church included 100 choirboys and almost 200 seminarians. In 1914, it was estimated that $10,000 was spent on palms from Florida for use on Palm Sunday in churches around the city. The largest dealer of palms handled 150,000 heads, which sold to the city's churches for 4¢ each. St. Patrick's Cathedral alone spent $1,000 on Easter flowers that year.

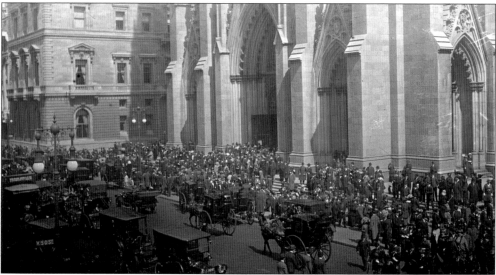

Easter has always been a big day of joyful celebration in New York City for Christians of all types. In this image from 1908, vendors sell Easter flowers in Union Square. Easter lilies have long been a symbol of both the renewal of spring and the ascension of Christ into Heaven.

The Easter parade is a chance for New Yorkers to show off their finery. This image shows Fifth Avenue on Easter in 1912. That year, Easter Sunday began with nice weather but by afternoon there were clouds, wind, and rain. Thousands of people walked along Fifth Avenue between Central Park and 42nd Street, with parade watchers positioned at key points such as outside St. Patrick's Cathedral.

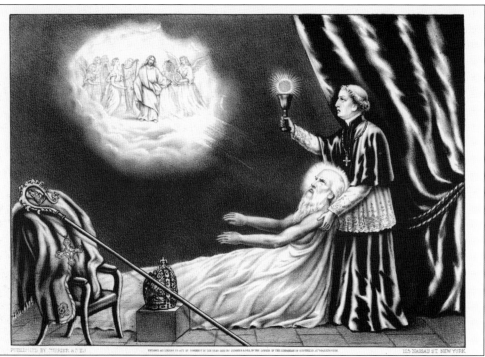

This Currier and Ives lithograph is titled "The Death of St. Patrick" and shows the death of Patrick at the Monastery of Saul in Ulidia at the age of 78 on March 17 in the year AD 465. The lithograph dates from 1872.

This is a poem by Patrick Moran of Brooklyn, written and published in 1861, probably intended to be handed out on St. Patrick's Day. In the poem, Moran sounds a rallying cry to the "Sons of Great Saint Patrick that now reside in New York town" to "hail the sacred festival of our renowned and pious Saint."

This print shows a grand Requiem Mass held in St. Patrick's Cathedral, on Friday, January 16, 1863, for the repose of the souls of the officers and men of the Irish brigade killed in the Civil War. New York's Irish Catholics contributed heavily to the war effort.

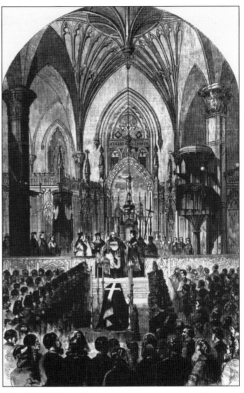

The first celebration in New York City was held in a tavern in 1756, and the first parade was held in 1762. St. Patrick is one of the patron saints of Ireland. In this image, a crowd of people watches the Kerrymen's Patriotic and Benevolent Association march in the St. Patrick's Day parade on Fifth Avenue in March 1909. The annual parade in New York has grown to become one of the largest and most anticipated celebrations in the city, although it is becoming less a celebration of the saint for whom it is named and more about Irish spirit.

St. Patrick's Day 1909 began with snow and sleet at 7:00 a.m. At the 11:00 a.m. mass in St. Patrick's Cathedral, Rev. Patrick Daly, dean of Dutchess County, preached the sermon. At 2:00 p.m. the sun finally came out; in the end, the parade started 55 minutes late. From a wooden platform, Archbishop John M. Farley reviewed the 12,000 men marching in the parade. There was one incident during the parade, when some children mounted the wooden rail of the archbishop's stage and part of the rail collapsed, sending a row of boys and girls five feet to the ground, but nobody was injured.

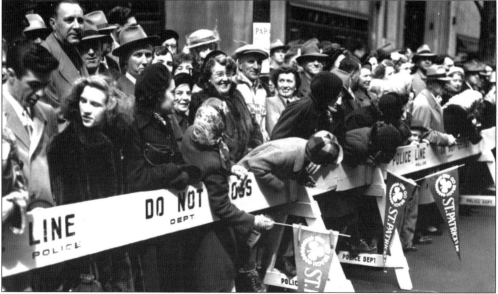

A crowd of people stand behind police barricades waiting for the St. Patrick's Day parade in this *World Telegram* photograph taken in March 1951. Every year, the St. Patrick's Day parade attracts New Yorkers and visitors of all nationalities and faiths and has become one of the best-known and loved parades in the entire world.

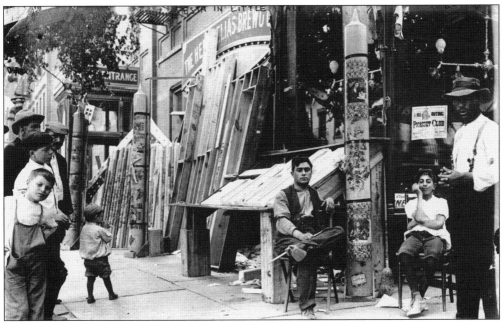

Feast days were commonly celebrated in Little Italy. These were celebrations of different saints. In the late 19th century, Jacob Riis described one such scene: "Around the corner came a band of musicians with green cock-feathers in hats set rakishly over fierce, sunburnt faces. A raft of boys walked in front . . . stepping in time to the music. Four men carried a silk-fringed banner with evident pride . . . almost every block has its own village . . . and with the village its patron saint, in whose worship or celebration . . . the particular camp makes reply to the question – 'Who is my neighbor?'" These images show goings-on during a feast day in 1908; some Italians gathered near a shop entrance and a vendor selling buttons in Little Italy.

The see of New York held a week of celebrations in 1908 in honor of the centennial of the founding of the diocese. At that time there were 1.2 million Catholics in the diocese, 856 priests, and 309 churches. Diocesan property at the time was valued at a total of $54 million. Michael Cardinal Logue, archbishop of Armagh and primate of all Ireland, came to New York City for the centenary festivities. The celebrations began on Sunday, April 26 at St. Patrick's Cathedral, where Archbishop Logue preached. On Monday, April 27, every parish in the city held a special mass for children. Two thousand children attended the children's mass at St. Patrick's Cathedral. The superintendent of schools granted leave to all Catholic children who wanted to attend. This image shows the County of Armagh Men's P&B Association reception for Cardinal Logue when he arrived in New York on April 25.

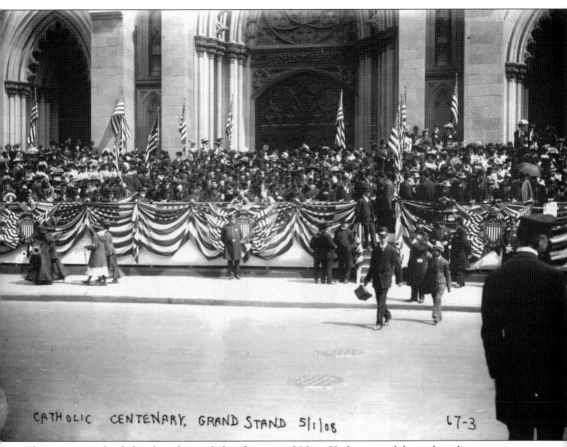

CATHOLIC CENTENARY, GRAND STAND 5|1|08 67-3

The centennial of the founding of the diocese of New York was celebrated with numerous special events. On April 28, a pontifical solemn mass was celebrated by Cardinal Logue. Present were Msgr. Diomede Falconio, James Cardinal Gibbons, archbishop of Baltimore, and 900 other members of the clergy. There were a total of 10,000 people inside and outside the cathedral. On April 29, 1908, a special High Mass was held for children of parochial schools. More than 5,000 children sang in a choir for that mass. On May 1, a votive mass of the Sacred Heart was held, opened by Bishop Charles Colton of Buffalo. This mass was followed by a grand parade. Forty thousand men of different Catholic affiliations and organizations assembled near Washington Square. At 2:00 p.m., the parade commenced.

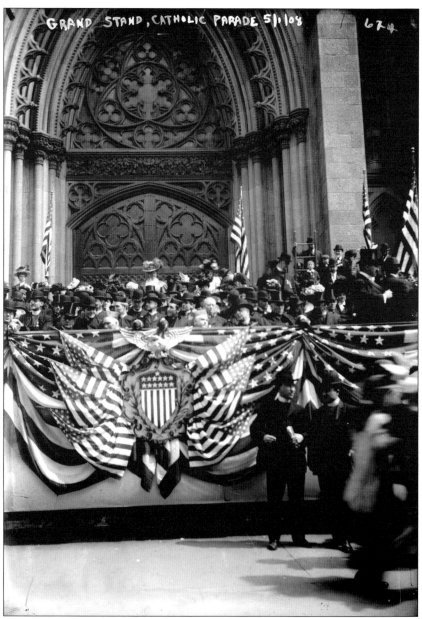

An estimated crowd of 500,000 people watched as the parade advanced toward St. Patrick's Cathedral. Stands holding 3,500 people had been erected outside the cathedral. Michael Cardinal Logue, visiting from Ireland, said of the centennial parade, "I never saw such an impressive gathering in all my life, and I never again expect to witness such a demonstration of loyalty to the Catholic Faith." This image shows people stationed in the grandstand that had been specially erected for the parade. After the celebration was done, the archbishop sent a message to all the churches in the diocese. He said, "The occasion gave birth to an enthusiastic manifestation of inspiring faith combined with ardent patriotism that our country has rarely, if ever, witnessed. . . . Every feature of the centennial festivities was carried out with perfect detail and complete success, which left nothing to be desired from the opening day of general thanksgiving in all the churches to the closing noon."

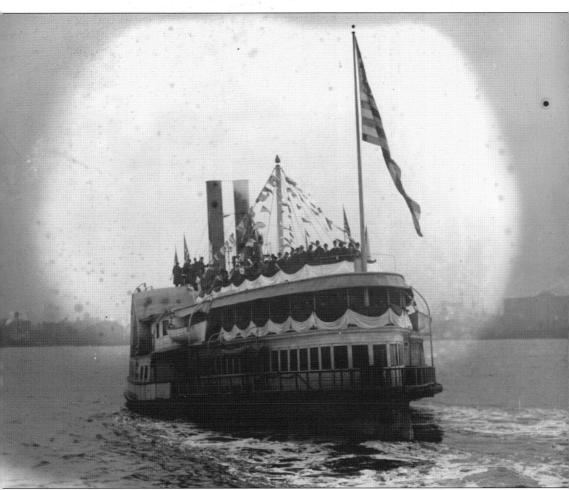

This image shows the steamer *Rosedale* taking Archbishop John M. Farley of New York and Diomede Falconio (apostolic delegate to the United States) to Hoboken, New Jersey, in November 1911. The two men were on the first leg of their journey to Italy to receive their elevation to cardinal. Before they left Manhattan, they went to St. Patrick's Cathedral, where they were greeted by 7,000 Catholic schoolchildren. Then a crowd of 21,000 lined the streets as the two left Manhattan for Hoboken. Once in Hoboken, they boarded the SS *Kronprinzessin Cecilie* bound for Europe. As the ship passed Pavilion Hill, Staten Island, another crowd of onlookers waved to the two cardinals-designate.

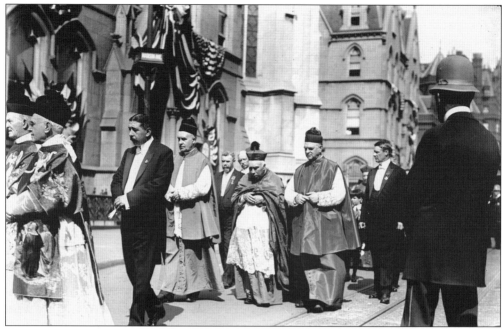

Consecration services are held when a church is free from debt. The consecration of St. Patrick's Cathedral on October 10, 1910, was a big event. It finally took place decades after the completion of the cathedral, as the great sum of $850,000 worth of debt was retired. There were 7,000 people inside the cathedral for the event and an estimated crowd of 50,000 people outside. Representing the pope was Cardinal Vincenzo Vanutelli. Michael Cardinal Logue, the archbishop of Armagh, also attended. Fully a quarter of the entire hierarchy of the United States was present. The sermon was preached by John J. Glennon, archbishop of St. Louis.

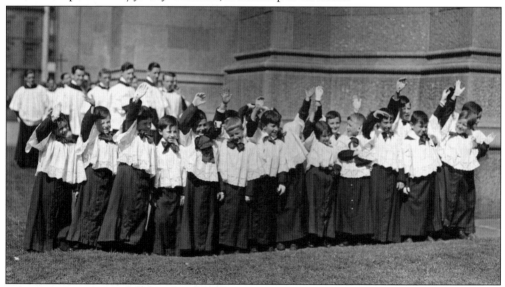

This undated image shows a group of children welcoming John Cardinal Farley at St. Patrick's Cathedral. The leader of the Archdiocese of New York always receives a great deal of attention, not only from local Catholics but also from the media. The activities of the archbishop have been described in newspaper stories for well over 100 years.

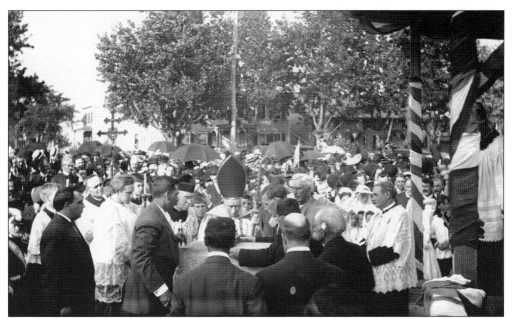

Cardinal Michael Logue (1840–1924), archbishop of Armagh and primate of Ireland from 1887 until his death, visited New York in 1908. He was shown around the metropolitan area by Archbishop John M. Farley. Among the sites they visited in early June were the Catholic Academy at Mount St. Vincent, Dunwoodie Seminary, and the future site of St. Raymond's church and school in Westchester County. Cardinal Logue is seen here laying the cornerstone for the St. Raymond School.

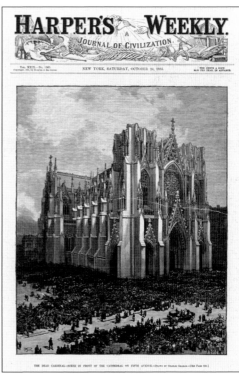

This image shows the crowds in front of St. Patrick's Cathedral in October 1885, where the body of John Cardinal McCloskey lay in state. Nearly every Catholic church in the city was represented at the funeral, along with many other churches from elsewhere in the country. The cardinal was laid to rest in the vault under the altar of the cathedral. This image is from the cover of the *Harper's Weekly* magazine, October 24, 1885, issue.

On December 28, 1908, a huge earthquake struck southern Italy. Estimates of fatalities vary greatly, but perhaps 150,000 people were killed, including at least 50,000 people dead in Messina and another 45,000 dead in Reggio. New York quickly came to the aid of the injured and homeless survivors. Archbishop John M. Farley sent out an appeal to all the priests serving churches in the archdiocese. The message said, in part, "I therefore ask that a collection in aid of these sufferers be taken up in the churches of the diocese at all masses on January 3. . . . Please make returns as soon as possible to the Chantry office that I may forward immediately the amount of collections to our Holy father, Pius X, who will dispense whatever aid may be gathered from the Catholic world." These images show collections being taken in downtown Manhattan. Collections came from many sources, including Chevalier C. Barsotti, the editor of the Italian-language daily New York City newspaper *Il Progreso*.

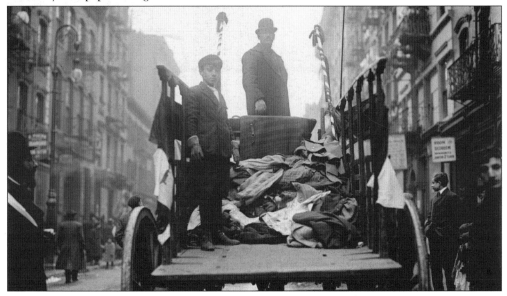

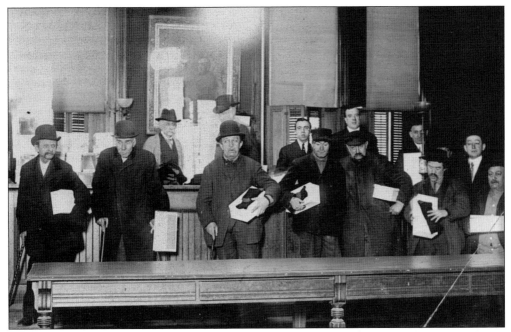

Tammany boss Timothy D. "Big Tim" Sullivan ran the charitable Timothy D. Sullivan Association, which in 1902 began an annual tradition of giving away shoes to the needy on February 6. This image shows the 1908 shoe giveaway at 207 Bowery. A three-block-long line formed, filled with needy New Yorkers who were eager to get one of the 5,000 pairs of shoes and stockings that were distributed.

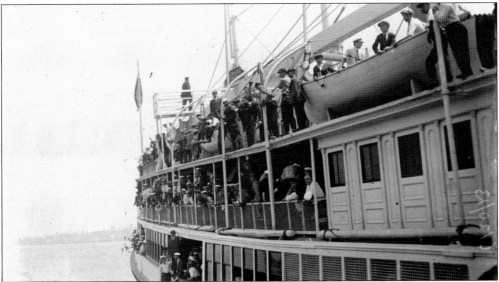

Many fraternal and charitable organizations in the city were led by Catholics, including the Timothy D. Sullivan Association. On June 30, 1913, the group held its annual chowder party. About 3,000 men met at association headquarters at 207 Bowery and marched to the East River, where a boat was waiting to take them to Donnelly's Grove in College Point. Once they arrived, lunch was served. Games included baseball and an obstacle race. Sullivan himself was not there; he was in broken health at the time.

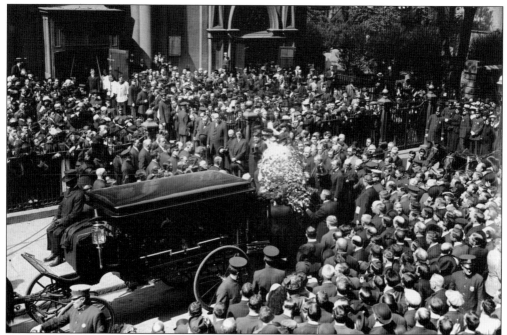

In late August 1913, Big Tim Sullivan went missing from his brother's home in East Chester. He was missing for almost two weeks, but in fact he was dead for most of that time, having been struck and killed on August 31, 1913, by a locomotive near Pelham Parkway. His body then lay in two different city morgues, unclaimed, until he was finally identified. As the news spread of Sullivan's death, plans for an elaborate funeral were made. On September 14, 1913, a viewing was held at the Timothy D. Sullivan Clubhouse, located at 207 Bowery. Fifty thousand people filed past to pay their last respects. There were over 100 floral pieces, the largest of which consisted of 3,000 roses and 2,000 chrysanthemums from the Sullivan Association.

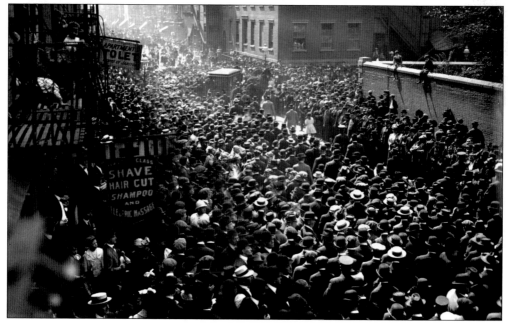